WEST MIDLAND CANALS

Severn, Avon *&* Birmingham

THROUGH TIME

Ray Shill

AMBERLEY PUBLISHING

First published 2012

Amberley Publishing
The Hill, Stroud
Gloucestershire, GL5 4EP

www.amberley-books.com

Copyright © Ray Shill, 2012

The right of Ray Shill to be identified as the
Author of this work has been asserted in accordance
with the Copyrights, Designs and Patents Act 1988.

ISBN 978 1 4456 1073 3

British Library Cataloguing in Publication Data.
A catalogue record for this book is available from
the British Library.

Typeset in 9.5pt on 12pt Celeste.
Typesetting by Amberley Publishing.
Printed in the UK.

Contents

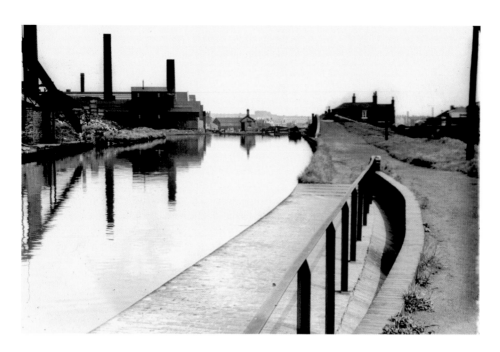

Birmingham Canal Navigations, Smethwick Locks
RCHS Photograph Archive, Weaver Collection 45071.

Introduction

This book is a study of waterways infrastructure and investigates through images and maps how the present midland network of canal and river navigations was put together. It is a complex history, where some working waterways are approaching 250 years of existence, while others have been constructed and modified throughout the period, right up to the present day. In some instances their existence has been sound and in others fragile. Many might have disappeared by now, were it not for a unique set of circumstances and a British passion for the past.

In 2012, English and Welsh canals and river navigations face one of the most of the most important challenges since their nationalisation in 1948, as waterways owned and maintained by British Waterways now pass into the control of the new Canal and River Trust. The present situation is further complicated by the fact that not all navigations in England and Wales were nationalised. A portion of the railway-owned canals had been abandoned and some independent canals had closed before that time, and thus these were not considered in the nationalisation package. Others, such as the Derby Canal, lingered on in private ownership until complete abandonment occurred.

Since 1948 the waterway network has undergone many changes. A core system has remained despite threats of substantial closures. While several of the surviving waterways were closed, restoration schemes have reinstated some of them to the network again, and other longer-term restorations look to further increase that mileage.

Commercial traffic was once the key reason for the navigations existence. Following its decline, other forms of water traffic have replaced it, mainly the 'pleasure boat' trade. The large numbers of these craft have kept the navigations open and necessitated the maintenance of the structures, some of which are now over 200 years old.

The Midland waterway network is diverse, with elements of both river and canal navigations. The different components were brought into use over a lengthy period, employing a wide range of old and modern materials. It was also a fertile training ground for those developing construction skills in the early years of canal construction, and enabled pioneering engineers and the contractors to progress to other work in different parts of the country. This sudden rush to build canals in the years 1792/93 has been dubbed the 'Canal Mania'. The 'Mania' was just as evident in the Midlands as elsewhere, with waterways interlinking much of the region and connecting tramways or plateways reaching parts inaccessible to the canal. Waterways engineering became an important discipline, on a par with the making of new turnpikes or tramroads. Skills continued to be honed and methods for building waterways improved.

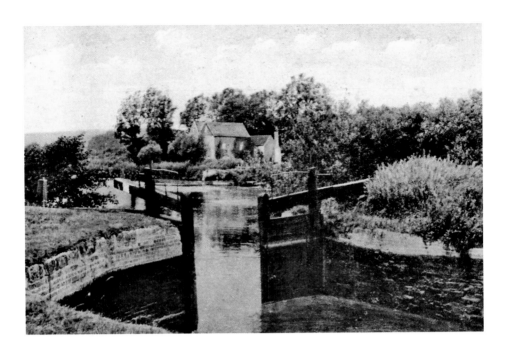

Lower Avon, Cressage Mill and Lock
The Warwickshire Avon navigation possessed a number diamond-shaped lock pounds. It is a design that has been linked by some researchers to William Sandys, who first made the river navigable. *RCHS Postcard Collection 95136.*

River Navigations

River Avon (Warwickshire), River Severn, River Stour (Worcestershire & Teme)

Navigation across Britain was at first restricted to coastal waters, estuaries and tidal rivers, but with the development of single-barrier 'flash locks', and later the upper- and lower-gated 'pound locks', navigation along sections of river became possible. River navigations were particularly improved during the seventeenth and eighteenth centuries. Craft made their way upstream along rivers such as the River Aire towards Leeds, the Bristol Avon to Bath, the Mersey and Irwell to Manchester, the Thames to Oxford and the Trent to Burton. Commerce benefited through such navigable links.

In the Midlands the two main rivers were the Severn and the Trent. The Severn flowed down from its source through Newtown, Shrewsbury, Worcester and Gloucester before reaching the Irish Sea. Such was the nature of this river that boats, at certain times, could reach Pool Quay or Llanymynech on the Vyrnwy that flowed into the Severn. The periods of higher water were known as 'springs' and they permitted trows to reach river quays at Shrewsbury and Ironbridge, helping the development of the iron industries there. The Trent was naturally navigable to Wilne (Cavendish Bridge). However, a major barrier was the medieval Trent Bridge in Nottingham, and the shallows and shoals further north limited traffic to shallow draught barges, which were referred to as 'Trent Boats'.

River navigation was improved firstly through the installation of single-barrier locks, placed often at weirs, which raised water levels for the water mills and enabled industrial processes such as corn milling, fulling and weaving through the power generated by the turning of a wheel. An important innovation was the pound lock, which enabled navigation of the Warwickshire Avon from Tewkesbury (on the Severn) to Stratford; it was partly completed by the start of the Civil War and work continued succesfully once peace returned.

Other rivers had less successful conversions. The Worcestershire Stour from Stourbridge to Stourport was provided with locks and the navigation lasted for some twenty years before abandonment. The River Salwarpe had locks provided for barges to reach Droitwich. How effective this was remains a matter of debate, with some historians claiming the work remained unfinished. Yet the fact that saltworks were established close to the river perhaps suggests that the navigation was successful.

The Severn remained a natural navigation, unfettered at this time by locks, which fact hindered access of narrowboats to this river. Later some determination on the part of certain canal companies and carriers led to the provision of horse towing paths along the banks of the River Severn in the West Midlands (1800–1812).

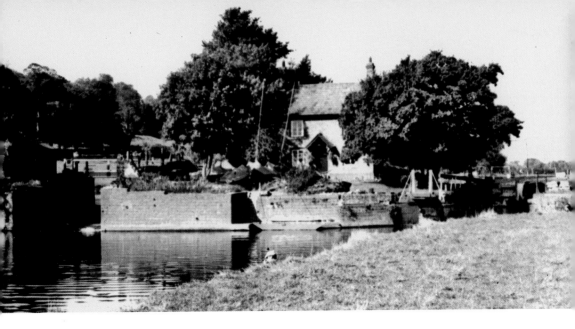

Lower Avon, Strensham Lock and Evesham Lock

Strensham (*above*) was one of the early battlegrounds in the struggle between William Sandys and Sir William Russell (sheriff of the county) in order to make the Avon navigable. The mill was on the Eckington side of the river and the principal objection was that the lock would cut the mill off from the Eckington bank. Sandys made a bridge and a version of this bridge remains as the swing bridge that can be seen right, in front of the lock chamber. Evesham lock (*below*) formed the boundary between the Upper and Lower Avon following the restoration of the former (1969–1974). This 1960s view by Philip Weaver shows the original arrangement, when the lock was the limit of navigation. Above the lock were located the weir and the pound that served Evesham Gasworks. *RCHS Weaver Collection 44793, 44834.*

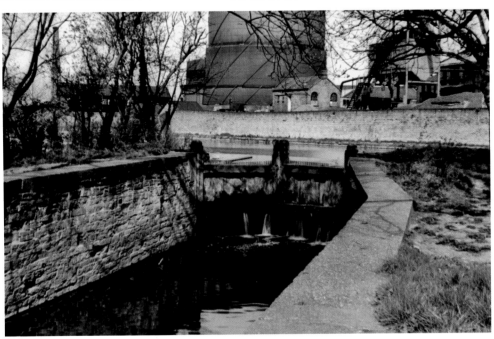

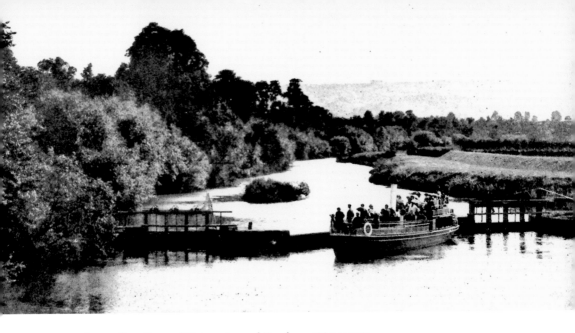

Lower Avon, Cropthorne Watergate and Pershore Watergate

The single-barrier watergate at Cropthorne (*above*) was a survivor from the early days of river navigation. The paddle gates either side of the 'lock' had to be raised to ensure the level was the same before the gate could be opened and the vessel pass through. Cropthorne Watergate was removed by the Lower Avon Trust in 1961 as part of their efforts to restore navigation to the river south of Evesham. The arrangement at Pershore (*below*) was slightly different to Cropthorne, but the principle was the same. The task of bringing craft upstream involved manual haulage. Winches were needed to bring a barge through the gate channel once the levels were equal, as the flow downstream remained strong. This watergate was removed by the Lower Avon Trust in 1956, leaving what remained as a shoal. *RCHS Hugh Compton Collection 64104; RCHS Postcard Collection 95137.*

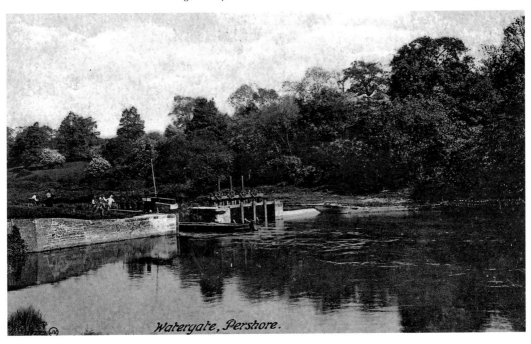

9

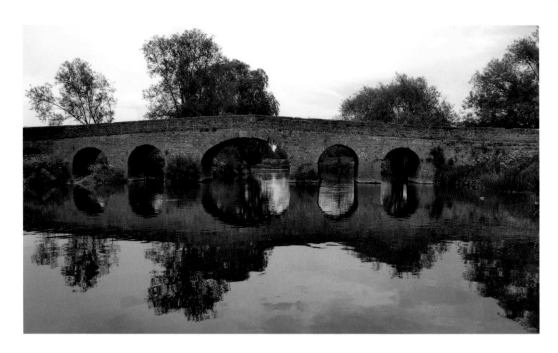

Lower Avon, Pershore Bridge and Pershore Mill

The crossing of the Avon at Pershore existed from medieval times at least, long before commercial navigation reached this point. In 1351 it was decided that the obligation for repair lay between the Abbot and the 'Men' of Pershore. Despite this decision the bridge decayed from time to time, as funds were frequently lacking. On 5 June 1644, Pershore Bridge was destroyed by the army of Charles I. The bridge today is a patchwork of different rebuildings and repairs, using both brick and stone, and comprises a central navigation arch with two river arches either side. There are several other flood arches that support the road crossing across the low-lying banks. Pershore in the fifteenth century had a fulling mill (*below*) for treating wool and later the town was associated with the stocking industry. In 1896 the proprietors of this mill were Goodwin & Sons, millers. *Ray Shill; RCHS Weaver Collection 44805.*

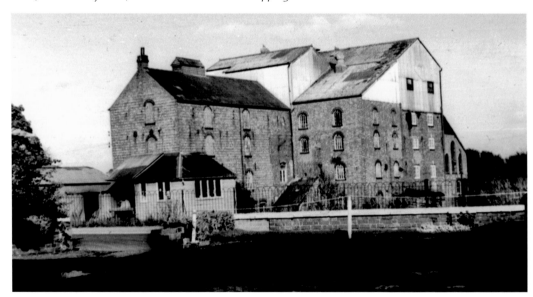

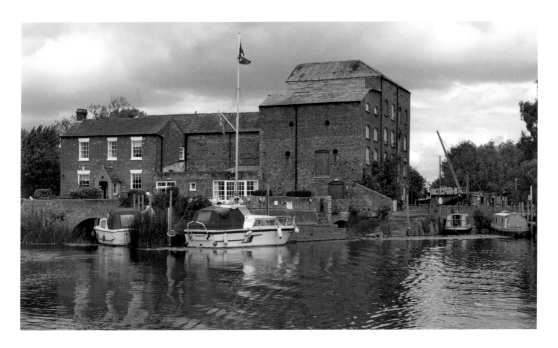

River Avon, Wyre Mill and Harvington Mill

The River Avon retains some impressive water mill structures. The mill at Wyre near Fladbury (*above*) came to occupy an extensive frontage by the River Avon. In 1896 'Wyer Mill' was occupied by Sharp Brothers, millers. Harvington Mill (*below*) is presently in an advanced state of dereliction. Yet in the nineteenth century this mill was used to mill corn and there was also a period when paper was made here. In 1896 the proprietors were the Vale of Evesham Flour Mill Company. *Ray Shill.*

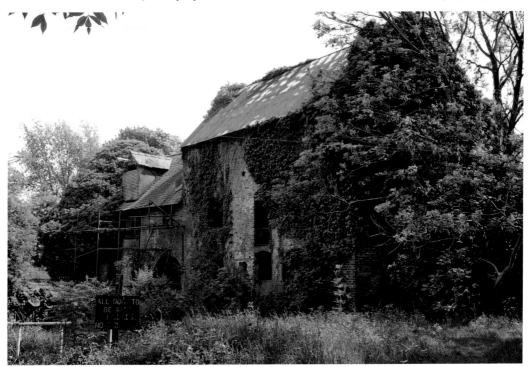

Early Canals

Birmingham Canal Navigation, Birmingham & Fazeley, Coventry, Droitwich Barge, Dudley, Oxford, Sir Nigel Gresley's, Staffordshire & Worcestershire, Stourbridge, Trent & Mersey

Artificial waterways began as links to river navigations, and if the cuts made by Romans (and the Exeter Canal) are excluded, the trend of commercial waterways in this Country expanded into the first purpose built navigations, or canals, during the Eighteenth Century. The first British Canal was the navigation through Newry to Portadown, which came to include river navigation, a ship canal and an inland canal that was completed in 1742. The first English canal was the Sankey Navigation (or St Helens Canal) authorised in 1755 which was constructed with locks to barge width and this was followed by the Duke of Bridgewater's barge canal from Manchester to Worsley Collieries, which was made under the direction of James Brindley. This work was so constructed that a single level was maintained between Castlefield and Worsley. A major engineering feature was the aqueduct at Barton that carried the canal over the River Irwell Navigation there.

Brindley had previously been involved in making surveys from Cavendish Bridge to Stoke and also from the Weaver, and out of his beliefs, and those of other engineers such as Smeaton, the concept of the watershed canal developed. Those route surveyed by Brindley followed river valleys and land contours, but not to the same extent as some of his contemporaries' later designs. Whether winding or not, the essence of these surveys was the supply from the watershed.

James Brindley gained a tremendous reputation through his skill in getting the Bridgewater built as well as start the extension through Sale to Runcorn. This later project would come to compete with the Mersey and Irwell Navigation. Parliamentary approval was crucial for any new venture. The Bridgwater extension succeeded because a guarantee of water supply from the Worsley mines was sufficient for the extension to be sanctioned.

Such was Brindley's skill and enhanced reputation that he became the preferred engineer to survey other projects. Most important of these were the canal from the Mersey to the Trent (the Grand Trunk) and the canal from the Severn to meet the Grand Trunk. These two schemes proved to be the embryonic start of inland navigation in England. The year these canals received parliamentary approval was 1766. Both tapped water from the summit level or watershed.

The first Welsh Canal to be authorised also was approved by the House of Lords that same year, and preceded the Brindley Canals, receiving Royal Assent in February 1766. This was a short water way called Khymers Canal that crossed level ground at Little Gwendraeth to coal mines in the Great Forest.

There was a certain amount of fortunate circumstance for James Brindley's schemes. The canal network may have been very different had parliamentary events of 1766 taken a different route. On 8 April 1766, the House of Lords Journal recorded the following:

Message brought from House of Commons by Mr Cholmondley and others

An Act for making and maintaining a navigable cut or canal from Witton Bridge to the towns of Nether Knutsford, Macclesfield and Stockport in the county of Chester and to Manchester in the county of Lancaster, to which they desire concurrence of this House

It was a scheme that perhaps should have passed the Lords, yet proceedings were stalled. Despite petitions in favour of what became known as the Macclesfield Canal bill, this bill was ordered

to 'lie on the table' and at the second reading on 18 April the case against and for the bill was heard. A powerful oppose of the bill was the Duke of Bridgewater and a number of witnesses were called for both sides. James Brindley provided a strong argument against the Macclesfield Canal Bill.

> Mr James Brindley, a surveyor who was sworn and examined as to the Utility and Practicability of the intended Navigation, the number of locks there must be made upon it, the nature of the manufactures [manufacturers] of the several towns near or adjoining to it, the difference there will be in the price of carriage on the Duke of Bridgewater's Navigation and the new one, the great injury the Duke is likely to receive by the taking of certain streams into the new canal which the Duke hath at great expense and difficulty brought into his navigation, the impracticability of carrying on the new navigation without taking in those brooks; and as to the depriving of several mills for grinding corn of water by the taking of those streams and the impossibility of his grace extending his navigation any farther, in case the said streams should be taken in.

John Golborne, of Chester, was the engineer responsible for the Weaver-Macclesfield Canal. His cross-examination by the counsel against the bill, delved into many subjects but in particular looked at Golborne's suitability and skills, if the decisions made for levels were accurate and if the water supply was practical.

Another day, 21 April, was taken up with more witness statements and at the end it was decided that the bill should be examined by a full parliamentary committee in three months' time. In this way proceedings for the Macclesfield Canal were stalled, while Brindley's two bills passed the Lords in May 1766 without trouble. They together with a bill to make the Soar navigable from the Trent to Loughborough went onto to be given the Royal Assent. Thus both the plan to make a waterway to Macclesfield and John Golborne were destined to become a footnote in transport history rather a leader, while James Brindley and his men gathered a reputation for new-build waterways.

Some historians have heaped on the accolades for Brindley, but his assistants and men also deserve credit, as do the clerk of works appointed to look after the building of each of his canal projects. In addition to the Trent & Mersey and Staffordshire & Worcestershire, Brindley was engineer to the Birmingham, Coventry, Droitwich (Barge) and Oxford in the West Midlands, and supervised each to varying degrees. His assistants Robert Whitworth and Samuel Simcox acted more in the roles of resident engineers, before tackling other projects later in their own right. Simcox can be specifically identified with the Birmingham and Oxford Canals. His preference for contour canals was especially noticeable on the original routes of both these waterways.

Construction of these early waterway schemes was hampered by the weather and tools were basic and limited to picks, shovels and wheel barrows. Making the canal was achieved by dividing up the work into short sections, where contractors would be employed with their men to dig the channel, excavate cuttings, barrow spoil and build embankments. Locks and bridges were made from handmade bricks and local stone, while tunnels were cut through as a mining venture might be, first sinking shafts and then making headings along the route of the tunnel. Bricklayers then lined the tunnel walls, roof and invert with bricks. Not all tunnels from this period were straight, as any boater navigating the tunnels along the Trent & Mersey at Preston Brook, Saltisford and Barton can testify. Yet they still serve as navigations to the present time.

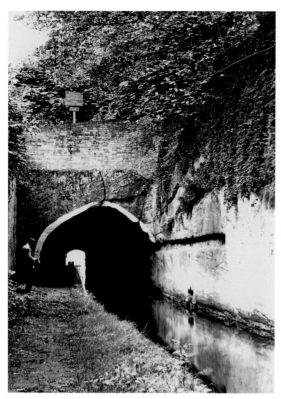

Trent & Mersey Canal, Armitage Tunnel and Cheshire Locks
Contractors building the canal near Armitage (*above*) encountered a bed of rock that required tunnelling. A narrow channel was cut through the rock and the towpath was carried through the tunnel. British Waterways opened out the tunnel. Locks such as Cheshire Locks, below, were made with stone and handmade bricks. Stone was often marked with the mason's mark. Two marks are evident on stones that form the lock chamber wall at this lock. *RCHS Hugh Compton Collection 65820; Ray Shill.*

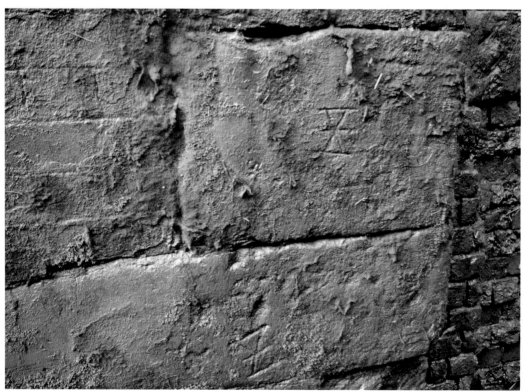

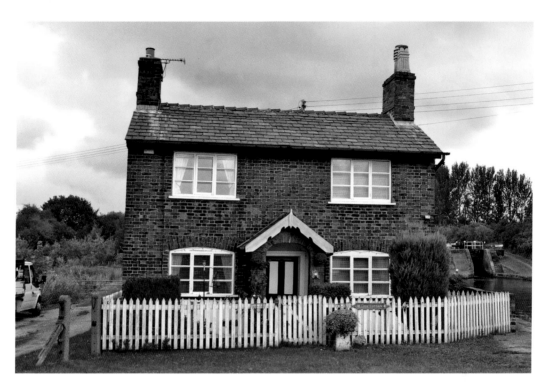

Trent & Mersey Canal, Cottage at Wheelock and Lock 56

This Trent & Mersey Canal cottage (*above*) is located beside the bottom lock (no. 66) in the Wheelock lock flight that forms the start of the long ascent to Kidsgrove Summit at lock 42, popularly known as Heartbreak Hill. While the canal west of the summit was widened by making a duplicate set of locks under Thomas Telford's direction, there were two locks, 55 and 56 (*below*), known as Pierrepoint Locks, which were never doubled and still retain the original format. *Ray Shill.*

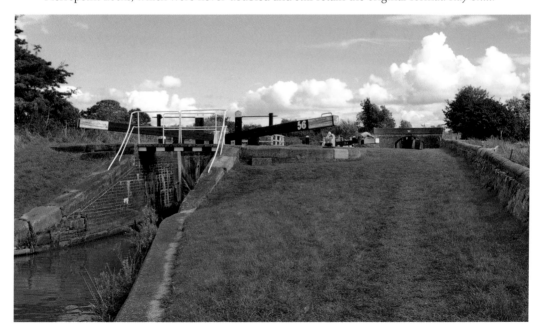

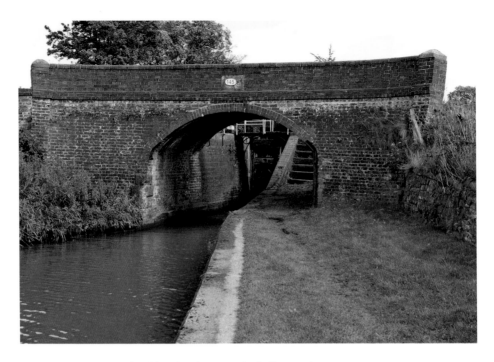

Trent & Mersey Canal Bridge (143) 145 and Chell Aqueduct
This bridge (*above*) placed between the two single locks is indicative of the style of lock chamber bridge as built under Hugh Henshall, engineer, following on from that adopted on the earlier construction work performed under the direction of Henshall for James Brindley. The rugged brick aqueduct (*below*) lacks the ornamental stone details of Thomas Telford's influence that are seen in on the east side of the structure. Instead it seems to be contemporary with Henshall's work on this section of the canal. The change in brickwork style on the west side is indicative of a subsequent widening. *Ray Shill.*

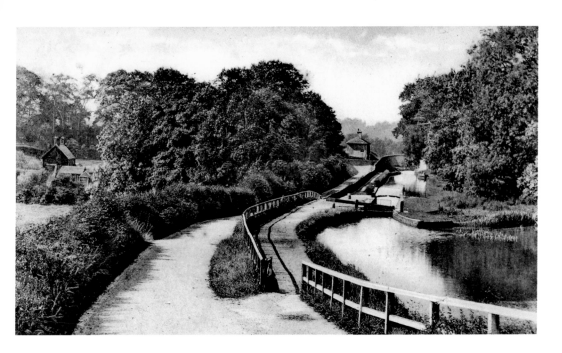

Trent & Mersey Canal, Meaford Locks and Fradley Junction

James Brindley's plan for the Trent & Mersey Canal included the construction of Staircase Locks at Meaford, Etruria and Church Lawton. All three staircases were replaced by a parallel line on conventional locks. At Meaford (*above*) the staircase route descended on the left-hand side of this view. Fradley Junction is seen below. The Coventry canal, in the foreground, joined the Trent & Mersey canal, midway on a flight of lock. The short level section (*below*) was crammed with different buildings including workshops. The range of buildings facing the junction included a public house (*centre*) and warehouse (*left*). *RCHS Postcard Collection 98117; Ray Shill.*

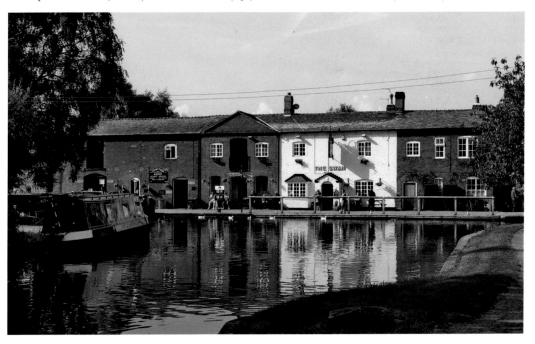

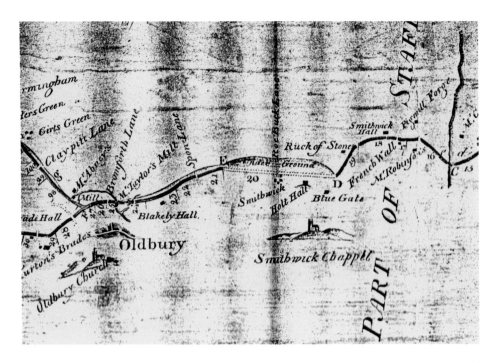

Birmingham Canal Navigation, Smethwick Tunnel Survey by James Brindley, and Smethwick Locks 4–6

According to the original plan surveyed by James Brindley in 1767, a level canal was maintained between Wolverhampton and Birmingham and a long tunnel was to be made between Spon Lane and Smethwick. When the tunnelling work between Smethwick and Spon Lane was abandoned, a flight of six locks were required at the Smethwick side to raise the navigation to the summit level. A similar set of locks were constructed on the Spon Lane side. *Heartland Collection 210401, 210502.*

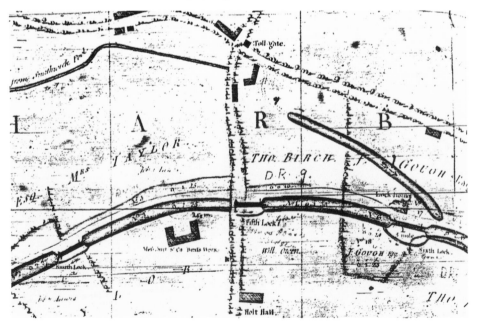

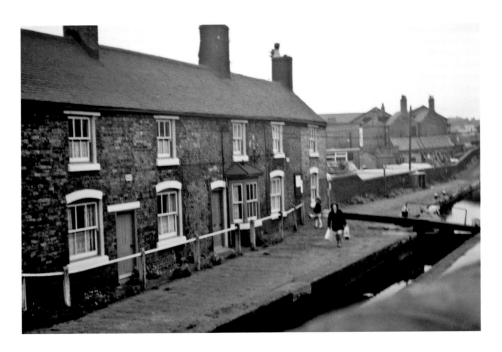

Birmingham Canal Navigation, Wolverhampton Top Lock

The twenty-one locks as they know are known were constructed first as twenty, with the last being made closer to the junction with the Staffordshire & Worcestershire Canal later. In the original James Brindley survey only seventeen locks were envisaged, but this was changed when the higher level from Spon Lane to Wolverhampton was created. A continuing feature of the canal here are the canal company cottages, two of which are seen below on the lockside. The bridge beyond the lock carries Little's Lane over the tail of the top lock and appears to date from the completion of the canal to this point in 1771. In the earlier view (*above*) the canalside from the Top Lock is seen as it was before landscaping. The towpath-side bridge (*right*) spanned the entrance to Hay Basin. *RCHS Transparency Collection 42007; Ray Shill.*

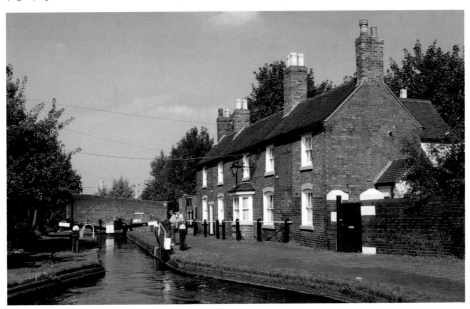

Birmingham Canal Navigations, Old Main Line, Coseley, and Roebuck Lane and Colliery Coal Drops

The Old Main Line, Coseley (*above*): This part of the BCN extended for some 22½ miles from Birmingham to Aldersley Junction. Brindley had surveyed a route some 5 miles shorter in distance, but the Birmingham Canal proprietors, influenced by the potential of increased trade, varied the route; Samuel Simcox translated their wishes into fact. The Jubilee Colliery concrete coal bunker (*below*) was completed between 1937 and 1938, replacing an earlier wooden structure and coal wharf. These facilities brought coal to boats moored to deliver coal to local factories and urban undertakings. Here the cutting is at the deepest level. Over a two-year period, George Beswick's men carted the spoil and sand in wheelbarrows to be dumped or dispatched by boat. *RCHS Weaver Collection 45075; Ray Shill.*

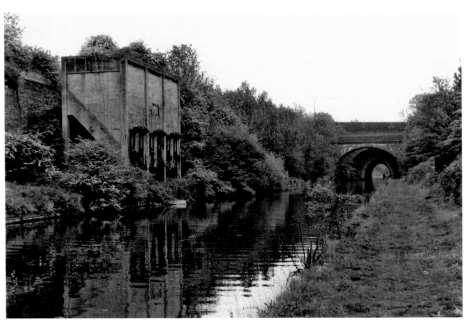

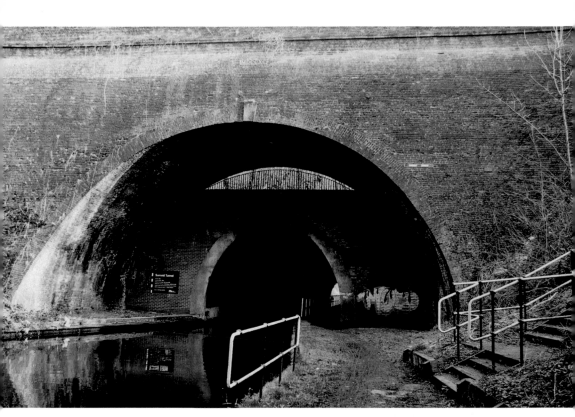

Birmingham Canal Navigations, Summit Bridge & Summit Tunnel, and Birmingham & Fazeley Canal, Livery Street Bridge
Summit Bridge (*above*) is a lasting monument to the work of James Bough, Samuel Bull and their men to reduce the summit. It was constructed to replace an earlier bridge that carried the old 491-foot (OD) level through a shallow cutting south of this point. Only the west side can now seen in full; that on the east abuts the modern, concrete-lined Summit Tunnel made to support Telford Way, which runs parallel to Roebuck Lane at this spot. On the Birmingham and Fazeley Canal (*below*), cutting the course of the Farmers Bridge flight of locks was undertaken by Thomas Sheasby and his men. While many of the bridges have been rebuilt or replaced, Livery Street Bridge retains the basic structure of the original. *Ray Shill.*

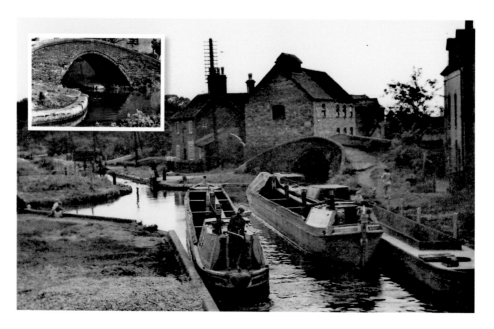

Coventry Canal, Atherstone Wharf and River Tame Aqueduct, 1958

The Coventry Canal Company reached Atherstone and ceased further construction until Thomas Sheasby took up the task of completing the canal to Fazeley. The temporary terminus at Atherstone was located on the right and in this view the original buildings stand (*above*). The side bridge that spanned the entrance to Atherstone Wharf (*inset*) would have been constructed during Sheasby's work on the extension. The three arches of the stone and brick aqueduct over the Tame near Fazeley (*below*) were the final part of the Coventry Canal to be completed. Thomas Sheasby experienced considerable difficulty completing the structure here, but finally the aqueduct was finished and the first boats were allowed to cross it on 13 July 1790. *RCHS Hugh Compton Collection, Photographer C. Faulkener 64402, 64403, inset 64400.*

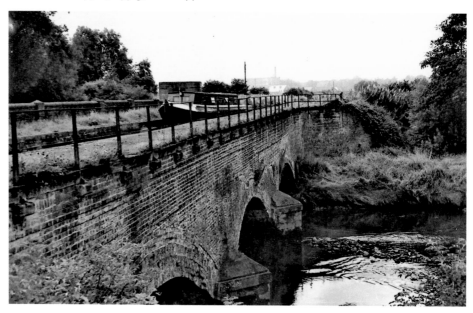

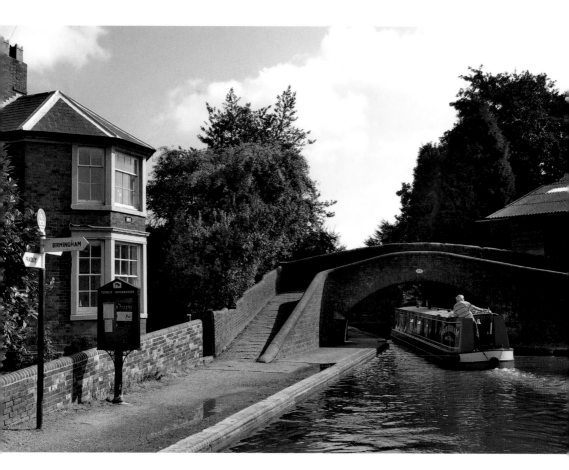

Birmingham & Fazeley Canal, Fazeley Junction

The joint venture that became known as the Birmingham and Birmingham & Fazeley Canal arranged for the construction of the canal from Farmers Bridge to Fazeley and a section of the Coventry Canal from Fazeley to Whittington Brook, which they retained control of. The toll collector's house (*left*) was constructed when the canal opened for traffic. *Ray Shill.*

Aris's Gazette, July, 1790

Communication by inland navigation between the ports of London, Bristol, Liverpool and Hull:

> *The aqueduct across the River Tame at Fazeley, in the county of Stafford, being nearly finished notice is hereby given that on Monday evening, the 12th day of July, the junction of the Coventry Canal with the Grand Trunk and the Birmingham and Fazeley Navigations will take place; thereby the long desired communication, by inland navigations, between the above mentioned ports be completely opened. The different traders on these canals may depend upon being enabled to navigate their boats over the said aqueduct early on Tuesday morning the 13th instant.*
>
> *Chambers and Homer*
> *Clerks to the company of proprietors of the Coventry Canal*
> *Coventry, 6 July 1790.*

Sir Roger Newdigate's Canals, Arbury Estate

These were a group of private waterways constructed to serve coal mines on the Arbury estate. These waterways linked with the Coventry Canal, by which means coal was dispatched. One side of the Arbury Estate was developed as the Griff Colliery, and Griff's Arm (*below*), which served the mines there, linked with the Coventry Canal at Griff Hollows and north of the other Newdigate Canals. *RCHS Weaver Collection 47505, 47503.*

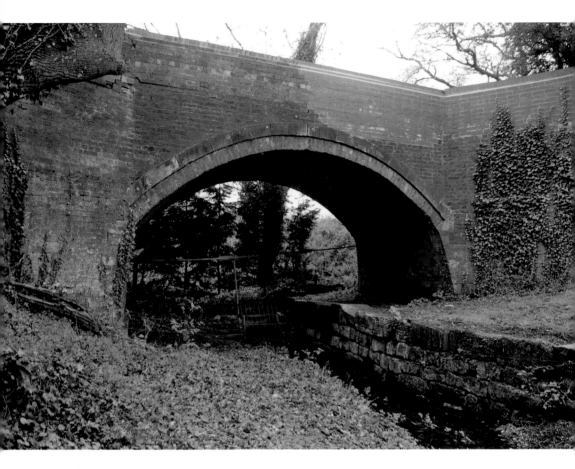

Donnington Wood Canal, Pave Lane
The Donnington Wood Canal was designed to link limestone mines and iron-smelting furnaces, and was constructed between 1767 and 1768. It was a narrow canal whose craft were small and square and could convey a weight of only 2–3 tons. These craft were known as tub boats. The terminus of the canal was at Pave Lane, where there was a wharf for unloading coal and limestone. Sections of the canal closed in a piecemeal manner, but most had closed by 1910. Despite the lengthy period of closure features remain, such as Hugh Bridge incline plane and brick bridges, including this repaired structure over the canal near Pave Lane Wharf. *Ray Shill.*

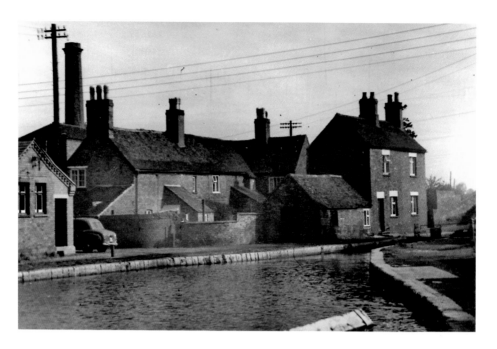

Oxford Canal, Hawkesbury Junction, 1958 and Brinklow Arches

The Stop Lock at Hawkesbury was a minimal 6 inches in favour of the Coventry Canal. The original junction was at Longford, but a new junction was made at Hawkesbury to reduce the journey made by craft passing from north to south, or vice versa, even though this involved nearly a 360-degree turn. The junction became a canalside community, and in this view (*above*) several now demolished buildings are to be seen. James Brindley's Brinklow Aqueduct (*below*) comprised a number of arches over the river valley. With the straightening and shortening of the main line the original stretch of canal was widened as a tall embankment, leaving the bulk of the aqueduct arches supporting the embankment. Only one arch was retained as a through-channel for the river. *RCHS Hugh Compton Collection, Photographer C. Faulkener 64405; RCHS Ray Cook Collection 60070.*

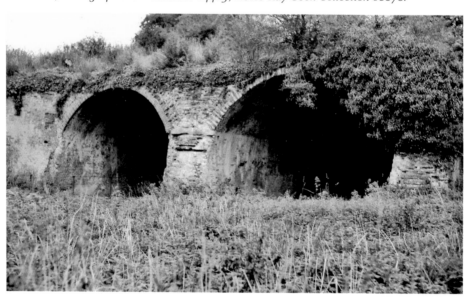

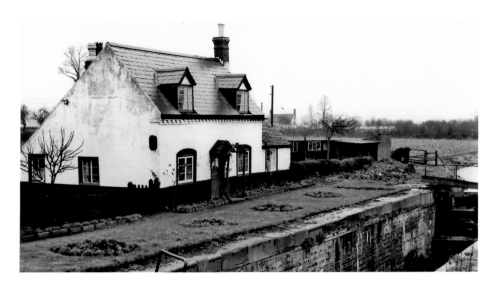

Droitwich Barge Canal, Ladywood Lock and Porters Mill Lock, 1957

James Brindley was engineer for the Droitwich Barge Canal, completed in 1771. Traffic primarily transported the salt produced around that town; many of the salt pans were relatively close to the canal. It carried in a type of barge known as a 'wich', hauled by hauliers or 'sailed'. Traffic ceased around the time of the First World War, although official abandonment did not occur until 1939. Ladywood Lock Cottage (*above*) remained as a home and there was even a garden and flower beds laid out along the lockside. For the keen-eyed, any navigation is visibly rendered impossible; the paddle gear has evidently been reclaimed for use elsewhere and the top gate balance-beam has been cut off. Another timeless scene is evident at Porters Mill (*below*). While nature gradually reclaims the lock chamber, there is still water in the main body of the canal. *RCHS Hugh Compton Collection, Photographer Ruth Brick 64479, 64483.*

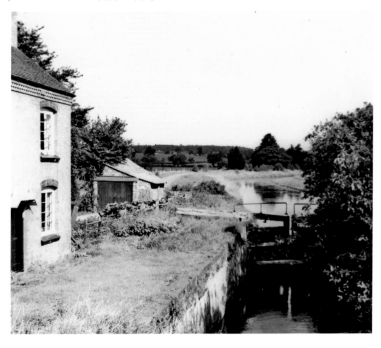

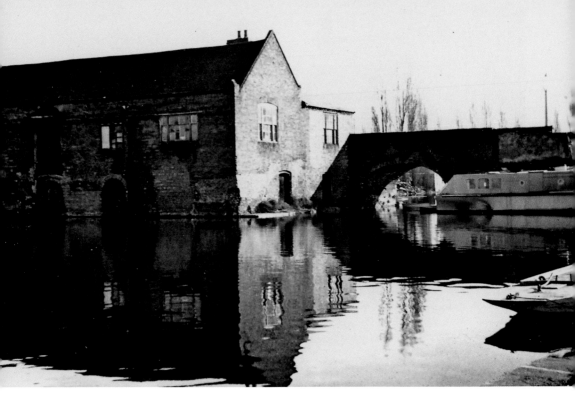

Staffordshire & Worcestershire Canal, Stourport and Caldwall Lock & Lock House, 1954

Above: The Staffordshire & Worcestershire Canal was constructed working down from the summit at Compton to Stourport, where a connection was made with the Severn. An important trading feature was the large basin, linked to the river by two barge locks. This basin came to have warehouses built around it and other side basins were also constructed. During the 1810s the Merchants Warehouse was constructed and Mart Lane Bridge was built when the far basin was excavated. Severn barges, or 'trows', were regular visitors to this upper basin, and they also passed under Mart Lane into the boatyards beyond. Here canal and river craft were repaired and constructed. *Below*: There were places on the canal where the river and canal came close together and the canal was cut through the rock side of the riverbank. Near Kidderminster, parts of the Stour required diversion to make way for the canal. *RCHS Hugh Compton Collection 65498, 65503.*

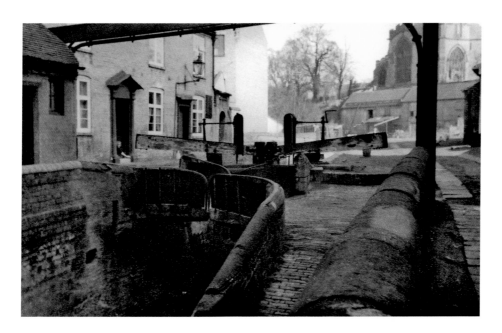

Staffordshire & Worcestershire Canal, Kidderminster Lock, 1954, and Gailey Round House

The Staffordshire & Worcestershire Canal passes close to St Marys Church, crosses the River Stour by an aqueduct and then descends through a Kidderminster Lock (*above*) to pass under the road. Here was located a now lost canalside community with cottages and a warehouse. A rare feature was the iron split-bridge that crossed over the tail of the lock. The descent from the summit level commenced at Gailey (*below*). Here also the turnpike and the Roman road Watling Street crossed over the canal below the tail of the lock. A feature was the circular round house or watch house, which is now a unique on this waterway. *RCHS Hugh Compton Collection, Photographer Ray Cook 65488.; Ray Shill.*

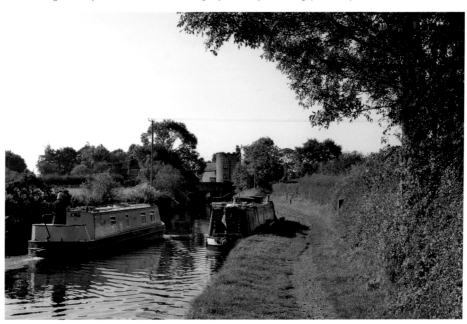

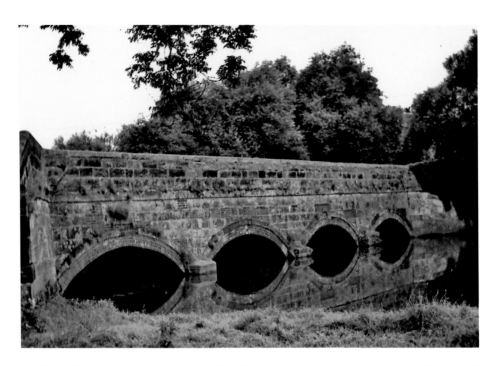

Staffordshire & Worcestershire Canal, Milford Aqueduct, 1958 and Stourbridge Canal, Leys Junction

Above: As work on the southern section of the Staffordshire & Worcestershire Canal from Compton to Stourport and the summit level neared completion, work started on the northern part, with contractors building sections of the route between Wolverhampton and Great Hayward, which included locks, bridges and two major aqueducts. One crossed over the Sow at Milford and the other spanned the Trent at Great Hayward. *Below*: The Leys was once a busy canal junction where boats either continued on to the Stourbridge Extension or turned right for the remainder of the main line than ran between Brettell Lane and the Delph. The route straight ahead also served as the link to the canal reservoirs. *RCHS Hugh Compton Collection, photographer C. Faulkener 65494; RCHS Weaver Collection 48066.*

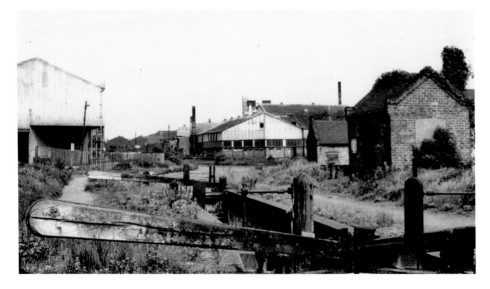

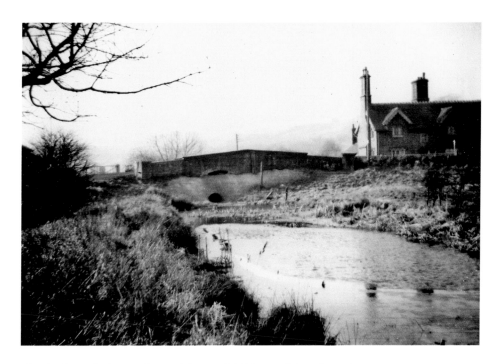

Sir Nigel Gresley's Canal, Apedale Road Bridge and Canal, 1956

The waterway from Newcastle-Under-Lyme to Apedale was constructed essentially as a tub boat canal that was isolated from the rest of the network. While schemes to include it into the national network, such as the Commercial Canal, were later promoted, no waterway link was made, even though a junction canal at the Newcastle end took the navigation within about 200 yards of the Newcastle-Under-Lyme Canal. It is possible that an incline plane may have been used to transfer items between the two navigations, as has been suggested based on sales adverts for the Apedale Ironworks. *RCHS Hugh Compton Collection 64820, 64821.*

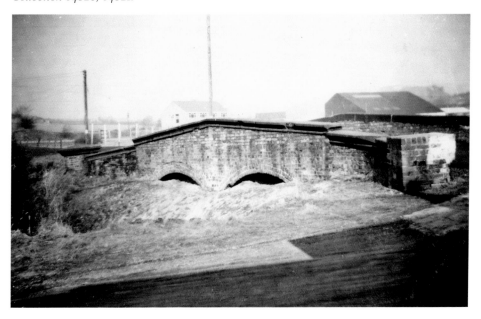

Canal Mania

Birmingham & Fazeley, Caldon, Hereford & Gloucester, Leominster, Nottingham, Stratford-Upon-Avon, Warwick & Birmingham, Warwick & Napton, Walsall, Worcester & Birmingham, Wyrley & Essington Canal

There was a period in which Parliament was inundated with new canal schemes. While most were practical and sound, others were put forward with less careful preparation. Key to this preparation was sufficient finance. Accumulating funds proved a considerable challenge for the canal builders; the traditional approach was to raise money by selling shares. The initial expenses were parliamentary, solicitors and surveying to get the scheme to the Bill stage. Other expenses were salaries for the directors, engineer, secretary and treasurer. Once the Bill became an Act of Parliament further costs arose: land purchase, contractor's payments, materials and boats. Any of these factors might delay the process, but success required a careful estimate of costs. Not every authorised canal from this period was commenced. Equally, some were never finished, and others had a protracted construction period. Revenue might never be fully achieved and those who financed such ventures were just as likely to lose money as profit from them.

Even the task of gaining parliamentary approval became a major hurdle to overcome. Every new canal scheme was opposed by those waterways already in operation. The Worcester & Birmingham faced a tough progress to get its bill, and further problems in construction. Had it succeeded Birmingham would have benefited by it. Finance issues delayed construction at Tardebigge and work was halted for a while. Here the intended barge locks became a project for a series of boat lifts. When the experimental boat lift failed to impress, the canal company chose the cheaper option of narrow locks instead. The legacy of this decision is the watery ribbon that descends around the hillside from Tardebigge to Stoke and remains a test for every boater that passes through this way.

The Stratford Canal was equally delayed. It was made as a barge canal from Kings Norton through to Hockley Heath, and then as a narrow canal through Lapworth to join up with the Warwick & Birmingham Canal at Kingswood. This part of the canal is known as the Northern Stratford and became a route chosen by certain Birmingham to London merchandise carriers keen to avoid the heavy lockage of alternative routes. The partnership of William James and William Whitmore led to some remarkable engineering structures on the extension to Stratford-Upon-Avon, made between 1813 and 1816. William James was both entrepreneur and engineer and had a wide vision for transport. He surveyed a route for the Liverpool & Manchester Railway, but could not complete the task before he went bankrupt. George Stephenson went on to complete the railway and James was consigned to obscurity as a result.

The Hereford & Gloucester and Leominster Canals were both conceived during this time and are examples of unfinished schemes. The Hereford & Gloucester Canal was built from the Severn as a narrow canal as far as Ledbury and lacked a proper water supply when it fell short of the intended destination. For the Leominster Canal, the failure to apply for a sufficient share issue led to the undertaking being undersubscribed and only a central section from Mamble to Leominster was ever opened to traffic. Others were more successful: The Caldon, Warwick & Birmingham and Warwick & Napton Canals were all completed to become useful parts of the growing British waterways network.

Northern Stratford-Upon-Avon Canal, Earlswood Pumping Engine House and Bridge 32, Lock 7, Lapworth Locks

The supply of water to the Stratford-Upon-Avon Canal was improved with the completion of Earlswood Reservoir (*above*). Complete with split iron bridge, lock 7 (*below*) was part of the flight completed by T. Cartwright and linked the temporary head of navigation at Hockley Heath with the Warwick Canal at Kingswood. *Ray Shill; RCHS Hugh Compton Collection, Photographer Philip Weaver 65556.*

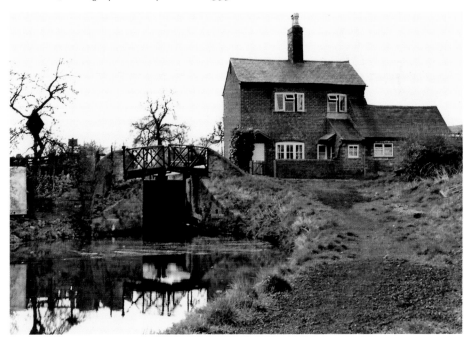

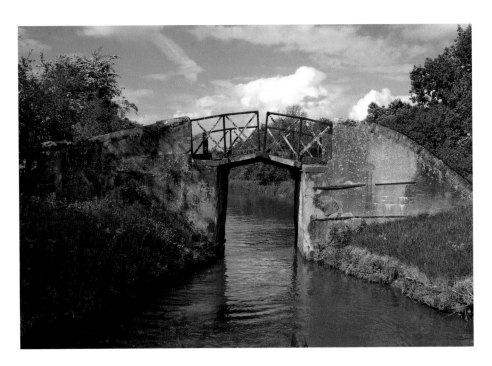

Southern Stratford-Upon-Avon Canal, Split Bridge and Lapworth Locks

The split bridge (*above*), in this form, is unique to the Stratford-Upon-Avon Canal and the remarkable association of the engineer William James and the engineer and ironfounder William Whitmore. It is a very simple concept to build accommodation and footbridge abutments of masonry, span a gap the width of a narrowboat through two inclined iron plates and arrange the plates so that a gap is left at the apex wide enough for the tow rope to pass through. The descent of Lapworth Locks ended with the link to the Warwick & Birmingham Canal (*below*). *Ray Shill.*

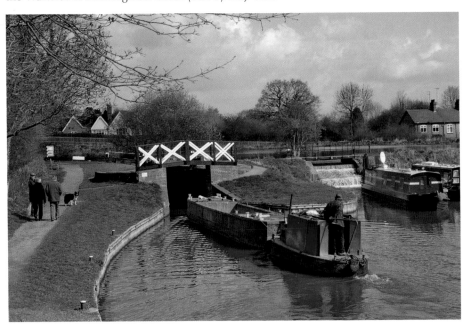

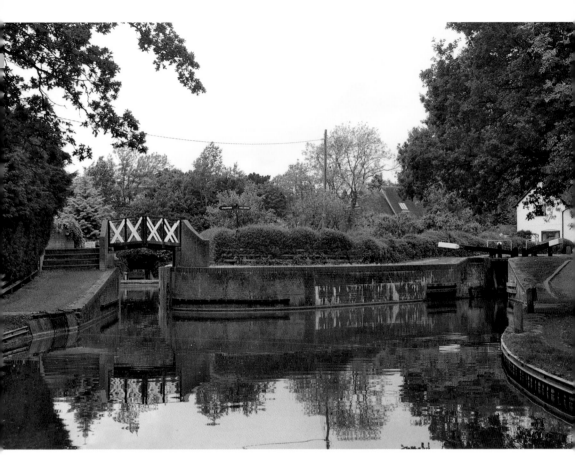

Stratford-Upon-Avon Canal, Kingswood

The canal in its original form linked the Worcester & Birmingham Canal at Kings Norton with the Warwick & Birmingham Canal at Kingswood. That channel passed along the course of the present left-hand waterway at a stop lock. Thomas Cartwright who constructed Lapworth Locks made the mistake of placing the last lock on the Junction Canal. When James & Whitmore went ahead with making the Southern Stratford, the Warwick & Birmingham insisted on a system that would not lose water from their own canal to the Southern Stratford. Space was limited, but James' original solution was a modification of the stop lock with a conventional lock gate at the Kingswood end and guillotine gate at the far end. The Warwick & Birmingham were not satisfied that such arrangements did not pass water from their canal onto the Stratford and pursued legal action in the court of Chancery. Their victory in this case forced the Stratford Canal to build a new lock (*right*) that compelled all boats passing from the Warwick & Birmingham onto the Southern Stratford (or vice-versa) to pass up a lock and then down again, inflicting additional water loss on the Stratford Canal company. The stop lock was filled in and forgotten about. British Waterways reinstated the link in the 1990s, digging out the original lock chamber, but faced with the same space constraints as James it was decided to widen the pound on the main waterway in order to ease the turn for boats. Unfortunately a section of the original lock chamber was removed as part of these alterations. The renovation work included the provision of a modern replica of a split bridge across the lock. *Ray Shill.*

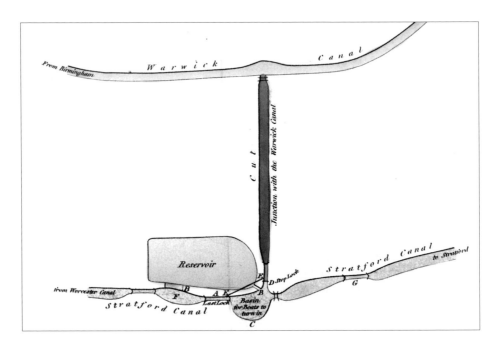

Extension to Stratford, 1813–1816 and Southern Stratford Canal, Barrel Roof Cottages
The arrangement at Kingswood as planned by William James (*above*) required a stop lock
(D), a storage reservoir and a basin wide enough to turn boats (C). In order to preserve
the supply of water to the Warwick & Birmingham Canal, a cast-iron pipe 19 inches in
diameter (E–F) drew water from the last lock (A) and conveyed it to the stop lock. Water
from the reservoir was run off into pound (C) to maintain a level a few inches higher
than the Warwick & Birmingham Canal. While this arrangement was only adopted for
a few years, the pipe, or part of it, is still believed to exist. Another example of James'
inventiveness was the barrel-roof cottage (*below*). The concept of bridge construction is
generally accepted as James inspiration for this design. Such buildings are unique to the
Southern Stratford Canal. *Birmingham Reference Library (MS275); Ray Shill.*

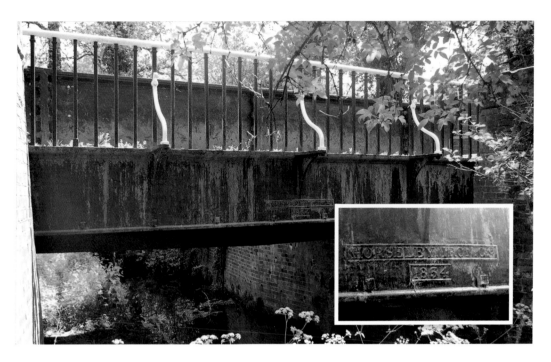

Southern Stratford, Yarningale Aqueduct and Lowsonford

William Whitmore provided three iron aqueducts for the Southern Stratford at Yarningale, Wootten Wawen and Edstone. That at Yarningale was washed away in a flood, but was rebuilt by the Horseley Iron Company of Tipton in 1834. Parts of the original structure are said to have been incorporated in the rebuild (*above and inset*). At Lowsonford (*below*), a minor road crosses the canal and is carried across the canal channel by an iron bridge. *Ray Shill.*

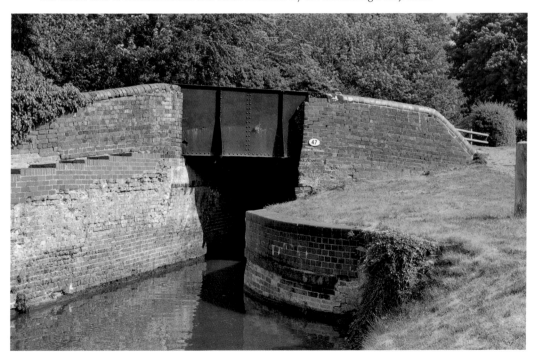

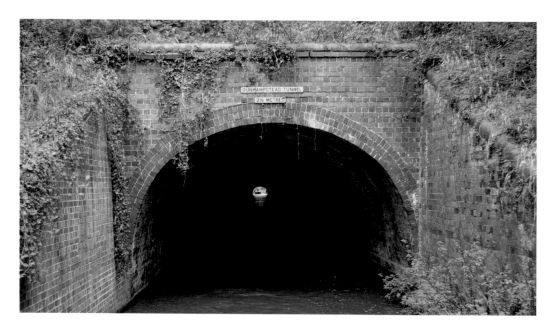

Worcester & Birmingham Canal, Dunhamstead Tunnel and Diglis

Dunhamstead (*above*) was the last tunnel to be built on the Worcester & Birmingham. It was the fifth along this waterway and was built to barge width like the rest. The frontage of the Diglis Warehouse (*below*), erected between 1815 and 1816 at Worcester, is now demolished. There were four separate warehouses initially. One was occupied by Pickford and another by George Ryder Bird. Diglis Basin (*inset*), like the upper Stourport Basin, was designed for narrowboats or Severn trows. The right-hand side was lined by warehouses, while the left was dominated by a tall flour mill. *Ray Shill; RCHS Kenneth Gardiner Collection 78211, inset 78214.*

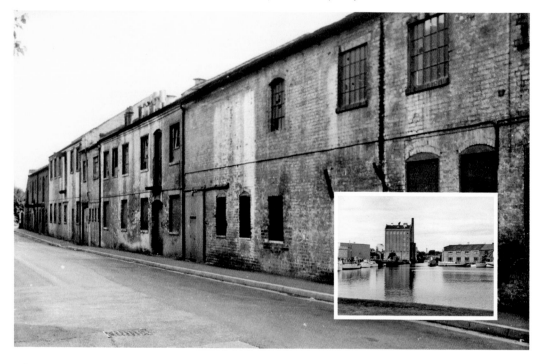

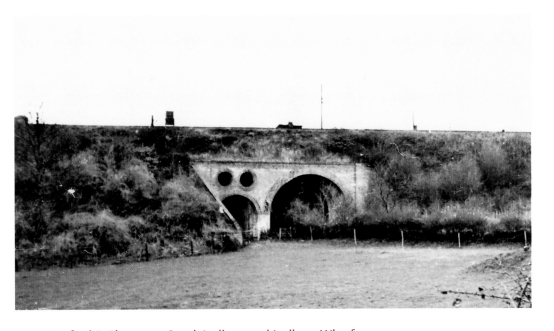

Hereford & Gloucester Canal, Ledbury and Ledbury Wharf

Stephen Ballard was the engineer for the building of the canal extension to Hereford from Ledbury and the contractor associated with Thomas Brassey for the construction of the Worcester & Hereford Railway. The railway crossed the Hereford & Gloucester Canal at Ledbury. The design, with a towpath bridge separate to the waterway channel bridge, was similar to that of the railway as it crossed the Worcester & Birmingham Canal at Lowesmere. Ledbury was the original terminus of the canal from Over at Gloucester. *RCHS Ray Cook Collection 60367, 60031.*

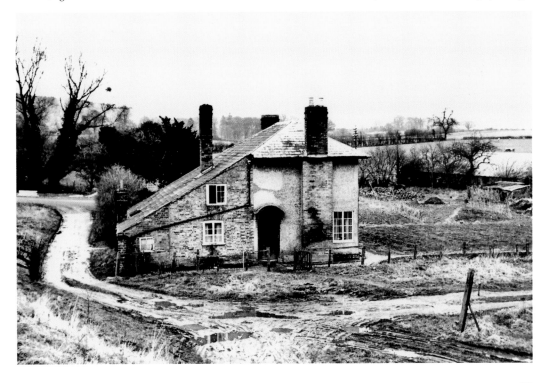

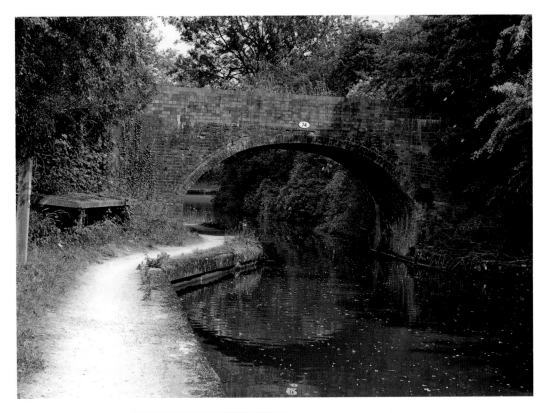

Warwick & Birmingham Canal, Bridge 74 and Hatton Locks Lock Cottage at the Bottom of the Locks While many bridges were rebuilt when this canal was improved by the Grand Junction Canal, a few original bridges remain, including bridge 74 (*above*). Hatton Locks Lock Cottage (*below*) remains beside the wide lock built for the Grand Union Canal Company. However the style and brickwork is much older and parts of the structure belong to the period when there was a flight of narrow locks here. *Ray Shill.*

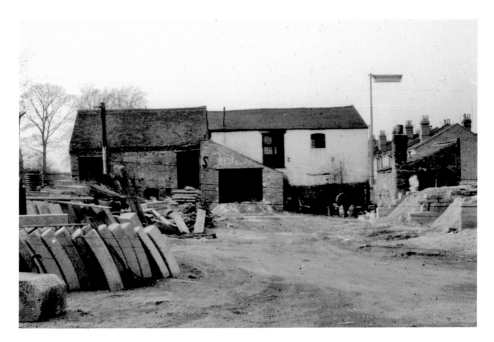

Warwick & Birmingham, Saltisford Basin & Wharf and Knowle Locks

Canal traffic to Saltisford Wharf (*above*), the terminus of the Warwick & Birmingham Canal, dwindled and with nationalisation of the canal network the arm and basin became disused; eventually part of it was filled in and built upon. The flight of locks at Knowle (*below*) comprised six narrow locks which carried the canal down to the level that stretched from Knowle to Hatton. In this view the side pounds are seen to the right. This image is said to have been taken around 1932, just before the locks were replaced with five barge-sized locks. *RCHS Weaver Collection 45616, 45628.*

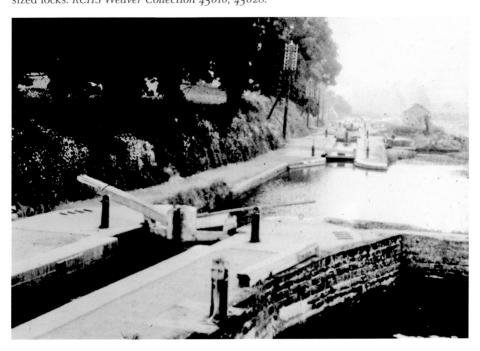

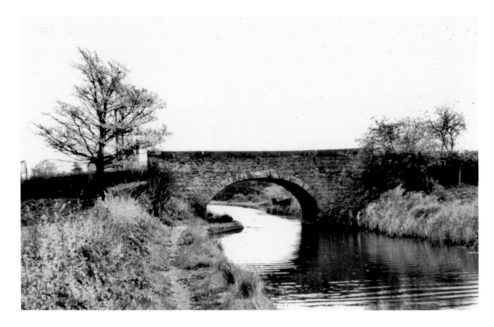

Warwick & Napton Canal, Radford Semele and Lock Cottage and Workshops

Above: There are similarities between bridges on the Birmingham & Fazeley, Coventry, Warwick & Birmingham and Warwick & Napton Canals. Of the few that survive, many are in rural locations where they still fulfil their purpose as occupation bridges linking one field with another. That connection may be an engineer in common: Samuel Bull, whose skill served all these undertakings at one time or another. Samuel belongs to that long list of people whose services to building the waterways deserve better publicity. *Below*: The Warwick & Napton Workshops were placed alongside lock 12 (lock 9 in the Stockton flight). The arrangement of buildings included the cottage, workshops and two stables (*right*). While the cottage remains, the workshops were demolished in 1964. *RCHS Weaver Collection 45675, 45655.*

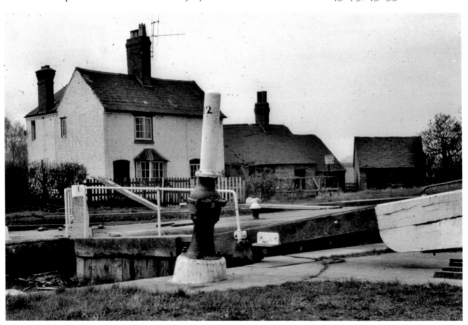

Birmingham Canal Navigations, Ocker Hill and Dudley Canal, Dudley Tunnel, Castle Mill Basin

Above: The engineering heart of the Birmingham Canal was located at Ocker Hill. It was here that their fleet of maintenance boats was repaired and constructed, the various infrastructure projects carried on and it was also here that a large pumping engine establishment was located, which recirculated water between the Walsall Canal and the Wolverhampton Level. *Below*: The line of Dudley Tunnel is not totally enclosed. There are two openings at Shirts Mill Basin and Castle Mill Basin where the canal is opened out. At Castle Mill the open canal is the meeting point of three separate waterways: the older Lord Ward's Canal Tunnel (*right*), the private Wrest Nest Tunnel (*top left*) and the Dudley Canal Company Tunnel (*bottom left*). *RCHS Photograph Archive, Weaver Collection 45381; RCHS Hugh Compton Collection 64502.*

Dudley Canal, Dudley Tunnel, Tipton Portal and Leominster Canal, Southnet Tunnel, East Portal, 1956

Tipton Portal (*above*) was originally the entrance of the private Lord Ward's Canal. It became part of the Dudley Canal when Dudley Tunnel was made from Parkhead to join up with the existing private waterway. Commercial traffic ceased using the tunnel in 1952. This 1958 view shows the result of the disuse of the waterway at the entrance of Dudley Tunnel. The Southnet Tunnel (*below*), on the other hand, never even came into use. It was intended for the Leominster Canal to link with the Severn at Stourport. The work included two long tunnels at Southnet and Pensax. It was the policy for contractors to start work on tunnels early, and so excavators and miners set to work, but it was never completed. There is no West Portal, but the East Portal remains as testament to the folly of insufficient investment that sometimes dogged the best-intentioned schemes. *RCHS Hugh Compton Collection, Photographer Charles Hadfield 64489, RCHS Ray Cook Collection 65032.*

Leominster Canal, Rea Aqueduct, 1970 and Newcastle-Under-Lyme Canal, Stoke, 1956
Above: Thomas Dadford was responsible for making the Leominster Canal, which involved the construction of tunnels, aqueducts and locks. The Rea Aqueduct was located on the navigable section of this canal and served in this role until the construction of the Tenbury Railway, which used the canal bed in parts for the railway. Since then the aqueduct has been abandoned and yet it remains, while the railway closed and ceased to exist. *Below*: The junction with the Trent & Mersey Canal at Stoke was placed in the centre of a group of commercial wharves. From here the Newcastle Canal turned south, then curved north to a terminus on the south side of Newcastle-Under-Lyme. *Hugh Compton Collection, photographer R. Russell 65041, 65234.*

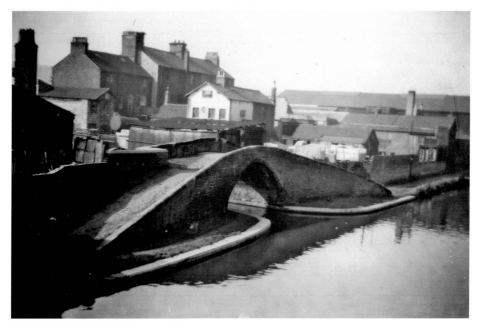

Wyrley & Essington Canal, Lock 24 Wharf and House and Sneyd Locks, No. 2

The Wyrley & Essington Canal made a descent some 7 miles long from the summit level at Brownhills to the Coventry Canal at Huddlesford and during the descent passed close to Lichfield. Lock 24 (*above*) was one of a group of locks beside the Tamworth Turnpike. The locks at Sneyd (*below*) were constructed by John Brawn and formed part of the original intended line to the coal mines at Essington and Wyrley. This part of the canal was opened by November 1794. The five locks in this flight would have been constructed using handmade bricks. The stone is said to have come from Tixall Quarry. The buildings adjacent to the locks were at first a farmhouse and later a public house. *Ray Shill; Jim Evans 627481.*

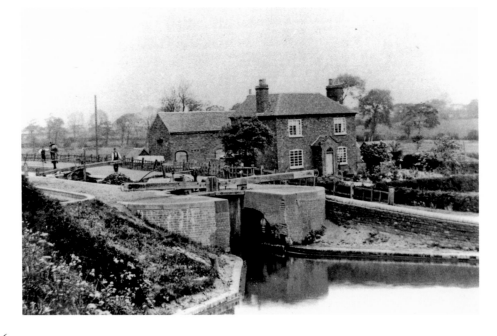

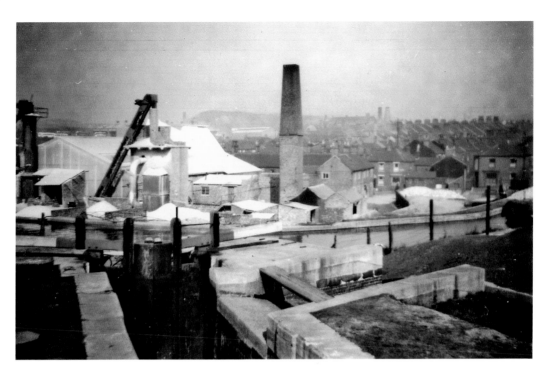

Trent & Mersey Canal, Rudyard Lake and Caldon Canal, Etruria Staircase Locks, 1956
Above: Situated north-west of Leek, this long lake was created through the damming of the valley provided an important supply of water to the Trent & Mersey Canal. *Below*: While the staircase pair on the mainline canal was elimated, the later staircase pair that served the Caldon Canal has remained. This waterway curved away from the junction with the mainline before making the climb to the higher level. *RCHS Collection 65829; RCHS Postcard Collection 98156.*

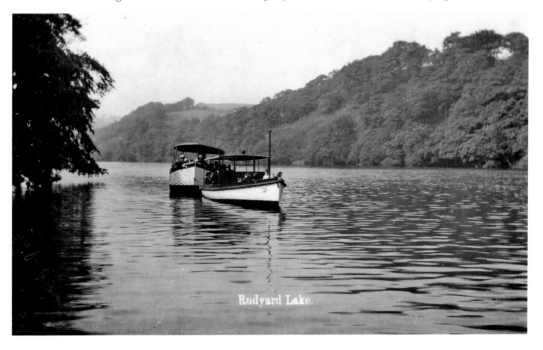

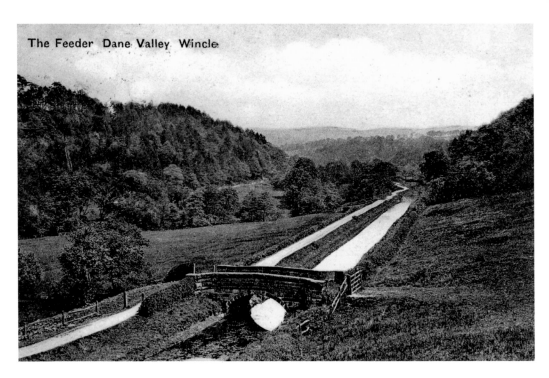

The Feeder Dane Valley Wincle

Trent & Mersey Canal, Rudyard Lake Feeder, Wincle, and Leek Basin, 1956
The construction of the long feeder from Rudyard Lake provided the means of channelling water from the lake to the Leek branch of the Trent & Mersey Canal, which in turn fed into the summit level of the this canal. *RCHS Postcard Collection 98153, RCHS Hugh Compton Collection 65852.*

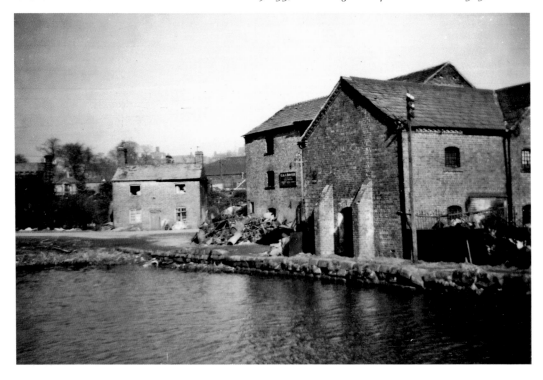

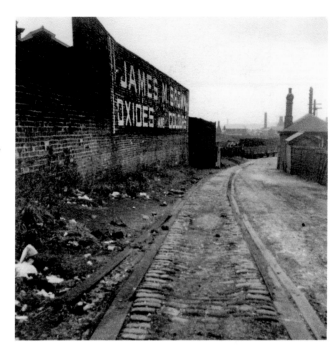

Trent & Mersey Canal, Lane End, Plateway and Uttoxeter Canal, River Churnet Crossing, 1958

The Trent & Mersey Canal operated four different tramways to link with its canals. One of these was the railway to Caldon Low Quarries (*above*). The Lane End system was the longest of the plateway lines and linked various pottery firms at Lane End with the canal basin at Stoke. The Uttoxeter Canal joined the Caldon Canal at Froghall and went onto a terminus at Uttoxeter. During the 1840s, it was closed with the making of an essential part of the North Staffordshire Railway through Leek and Cheddelton to Uttoxeter. In the view below, the route of the navigation crossed the river on the right-hand side and the tree is actually growing on the site of the flood lock chamber. The towpath was on the right-hand side of the navigation here and a footbridge (*inset*) is shown on Ordnance Survey maps crossing the river linking the two parts of the towpath. *RCHS Bertram Baxter Collection 21019; RCHS Collection, Photographer A. P. Voce 65868, inset Photographer A. P. Voce 65869.*

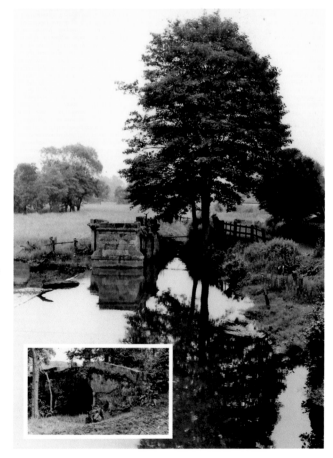

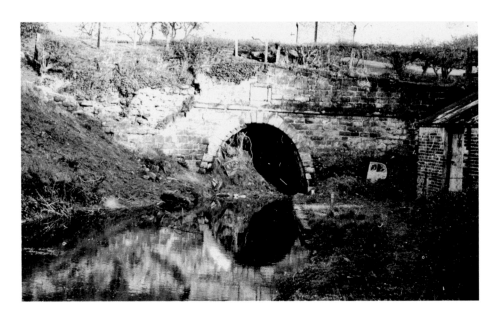

Shrewsbury Canal, Berwick Tunnel, c. 1965 and Shropshire Union Canal, Trench Incline Plane

East Shropshire adopted a system of waterways known as tub boat canals. The two main waterways were called the Shropshire Canal and the Shrewsbury Canal, and there were three others that connected with this system that were known as the Donnington Wood, Ketley and Wombridge Canals. The two main canals formed a united system of waterways that linked Shrewsbury with Coalport and served many of the major ironworks in the district. The image below is often quoted as being taken in 1921 when the incline was abandoned, although an alternative date of 1895 is also possible. With the partial abandonment of the canal by the LMS Railway, traffic on this part of the waterway ceased. Berwick Tunnel (*above*) then became disused. *RCHS Transparency Collection 75435; RCHS Weaver Collection 47964.*

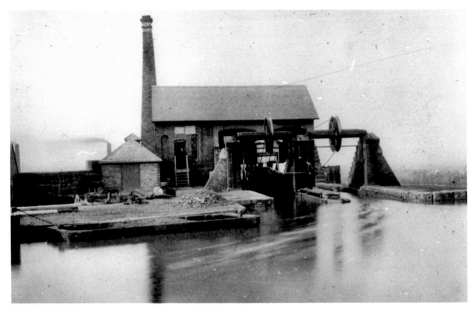

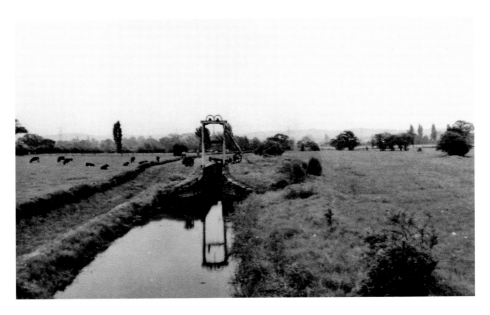

Shrewsbury Canal, Eyton Lock, 1954, Trench Incline Plane and Dawley Aqueduct
While the Shropshire Canal was noted for changes of levels using incline planes, the gradual slope of the land towards the Severn at Shrewsbury was better adapted to locks. From the bottom of the sole Shrewsbury Canal at Trench there was a series of tub boat locks. Each had a chamber 80 feet long and was capable of passing up to four tub boats at a time. While much of the Shropshire Canal became disused with the making of the LNWR Coalport Branch, the Shrewsbury Canal was left intact and Trench incline remained in use. It ascended to the level of the Wombridge Canal, which formed links with the Shropshire Canal and the private Donnington Wood Canal. It is perhaps the only junction where three separately owned navigations once met. The canals of East Shropshire also had some more conventional structures, including this aqueduct near Dawley (*inset*). *RCHS Ray Cook Collection 60091; RCHS Weaver Collection 47965; inset RCHS Ray Cook Collection 60112.*

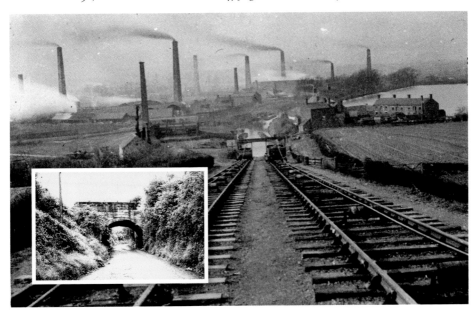

chapter four

Engineering Skills

*Birmingham & Liverpool Junction, BCN New Main Line, Macclesfield, Oxford Canal
(Shortenings) Stourbridge Extension, Trent & Mersey Canal (Improvements)*

The skills learnt from canal construction were adapted for building traditional stone-block and iron-rail tramroads. They also found better and more organised ways of building canals. James Brindley had concentrated on using river valleys and then followed the watershed to cross over to the other side. Some of his contemporaries specialised in following land contours rigidly for the route of the canal. During the period of canal mania more substantial infrastructure came to be made, as valleys were crossed with embankments and hillsides split by cuttings or cut through as tunnels.

By 1825 canal construction, like the early passenger railways, had become more direct. Such work was more costly as it frequently involved extensive engineering, yet the traditional skills of engineers like Thomas Telford were called upon. There were a number of ambitious ventures, few of which were built. Those that were possess important infrastructure.

Such skills were aptly demonstrated when Thomas Telford engineered the New Main Line for the Birmingham Canal Navigations making first the embankments and cuttings at Ladywood before making the straight canal through Winson Green to Smethwick. At Smethwick, Telford's resident engineer William Mackenzie faced the harder task of cutting a new and deeper channel, 20 feet below the level that James Bough and Samuel Bull had achieved some thirty-five years earlier. Telford also improved the water supply, eliminating the need for Smethwick Reservoir and replacing it with a new reservoir created through the damming of the valley that carried Edgbaston Brook through to Hockley.

The Birmingham & Liverpool Junction Canal was Telford's answer to the failed Birmingham & Liverpool Railway. This waterway was constructed as straight as possible with tall embankments and deep cuttings and with locks restricted to specific spots. Carriers found this a useful route to reach Liverpool even if it retained the requirement to tranship all goods into flats at Ellesmere Port. This route also provided an essential link with the isolated East Shropshire tub boat system. The building of the Norbury–Wappenshall branch, opened at the same time as the mainline in 1835, created a navigable link to the Shropshire iron trade, which had up that time been restricted to the water levels of the Severn or the road carrier's wagon.

Another important waterway from this period was the Macclefield Canal. Like the Birmingham & Liverpool it provided an alternative route for the carriers. It forged a route from the Trent & Mersey Canal north of Kidsgrove to join up with the Peak Forest Canal at Marple, opening up another route to Manchester and also other places such as Stockport, Oldham and Huddersfield. The canal itself is a remarkable study in stone, built using masons skills the stone from nearby quarries. The engineering involved embankments and cuttings, but only one flight of locks was necessary. These were built at Bosley and have a commanding view of the local hillsides.

The Trent & Mersey Canal with Telford's assistance made various improvements to the main line, which included the doubling of locks between Wheelock and Kidsgrove. Most of the original locks on this section were supplemented with the making of another lock on one side or the other of the existing locks. Lengths of canal, including aqueducts, were also widened to improve boat movements to Anderton and Preston Brook.

One venture that failed was the London & Birmingham Canal, as put forward by Thomas Telford. It was a scheme that was revised from time to time, but had the backing of West Midlands businessmen. His scheme was to link the Stratford and Warwick & Birmingham Canals with a straight waterway to Braunston, thus avoiding some of the difficult lock flights all boats had to contend with. His scheme was never taken up, but the Oxford Canal Company proposed and built an alternative, straighter route between Wyken and Napton, eliminating many of the loops and bends with a much-improved navigation. Such work was carried out by contractors working for the canal company and involved the building of a new tunnel, embankments, deep cuttings and aqueducts.

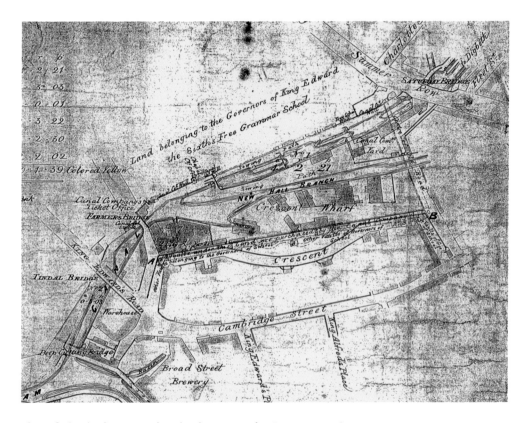

Plan of Birmingham Canal and Wharves at the Crescent _c._ 1842
The original temporary terminus (constructed in 1769) of the Birmingham Canal was beside the old Dudley Turnpike. This waterway was extended across the turnpike by an aqueduct to the wharves in Newhall Street (1771/72). It was one of two termini branches made in Birmingham for the canal company.

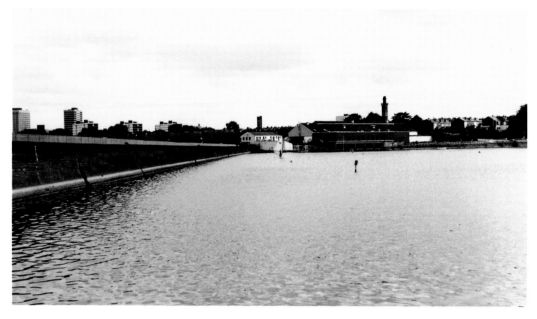

Birmingham Canal Navigations, Edgbaston Reservoir and Icknield Port Junction

Edgbaston Reservoir was constructed to the instructions of Thomas Telford as part of the improvements for the water supply to the Birmingham Canal. His major work was the building of the New Main Line. In this view the older Icknield Port Loop turns off to follow the valley of Edgbaston Brook, crossing at the valley head before turning back towards Eyre Street and Winson Green. The New Main Line continued straight on across the Edgbaston Brook Valley on a tall embankment. The land between the loop and embankment was gradually filled in and developed for industrial use (1870–1900). The Bellis & Morcam Engineering Works (*right*) was made during this time. *Ray Shill.*

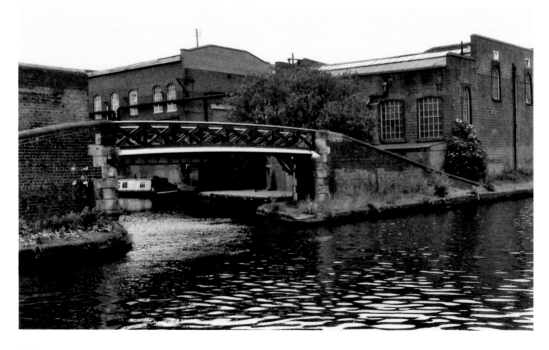

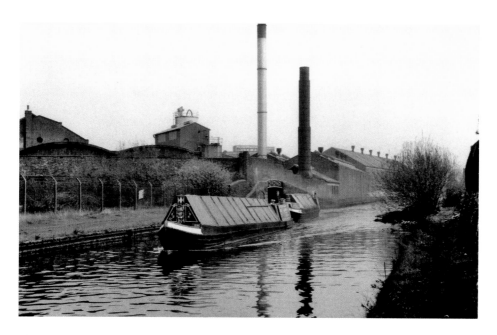

Birmingham Canal Navigations, Soho Foundry and Brasshouse Lane, Smethwick

Above: The improvements included straightenings and widenings on the canal through Smethwick and Winson Green. The old route that went beside the Boulton & Watt Foundry was partly infilled, but two basins remained at either end. Their entrances were spanned by brick and iron bridges. The northern basin served the Soho Foundry, which still sent out the bulk of its products by narrowboat. *Below*: There are three periods of canal history in this view. James Brindley originally intended to make a tunnel through the hillside. However, quicksand was encountered and the scheme was abandoned in favour of a flight of locks. The canal from lock 4 ran to the far left of this view. Between 1788 and 1791 the summit level was lowered to reduce the delays on the Smethwick and Spon Lane Locks. The Old Main Line level of 473 feet OD was created and formed the left-hand waterway. Finally, Thomas Telford created the 453-foot OD level seen on the right of the picture. *Ray Shill.*

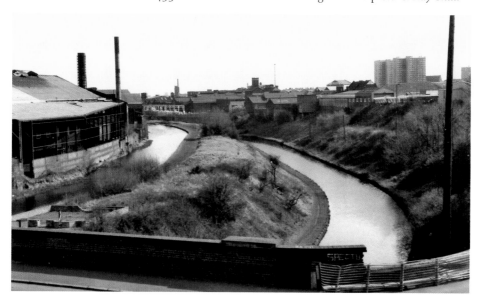

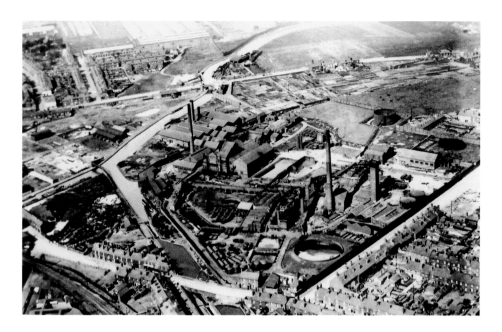

Birmingham Canal Navigations, Titford Canal and Old Main Line

The Titford Canal was opened in 1837 to provide a canal link to coal mines near Oldbury and Rowley Regis. It also provided the means of transport when chemical, phosphorous and tar works were established close to the line of this waterway. A pumping engine house (*below, seen top-centre*) enabled water to be pumped back to the summit level as compensation for water lost from the locks. The winding course of the Old Main Line can be seen in the top-right of the lower image, and centre-right the junction with the Titford Canal is visible, as is the long turnover bridge that united towing paths for both waterways. In the main part of this view is the Midland Tar Distillery. This scene changed a lot when the gas and tar trades ceased. The Old Main Line was also covered by the concrete viaduct that supported the M5 motorway, which followed the narrow transport corridor here. *Heartland Press Collection 649103; Ray Shill.*

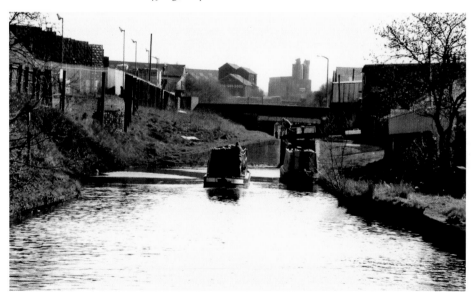

Dudley Canal, Lodge Farm Reservoir and Canal Widening Near Primrose Bridge

When the Dudley No. 2 Canal was constructed between Selly Oak and Parkhead, the line near Saltwells Coppice was convoluted; following the contours of the land, the route involved some sharp bends. This section was eliminated through the making of Brewins Tunnel, which diverted the waterway under the hillside. The old route was adapted as new reservoir, which became known as Lodge Farm. The remains of the old canal bed lie at the bottom of this reservoir. Another improvement to the Dudley Canal was the cut across the corner of a turn near Primrose Bridge. The improvement created a wide piece of water where a basin was made. The structure standing beside the basin was a proof house for chains made in the area. *Ray Shill.*

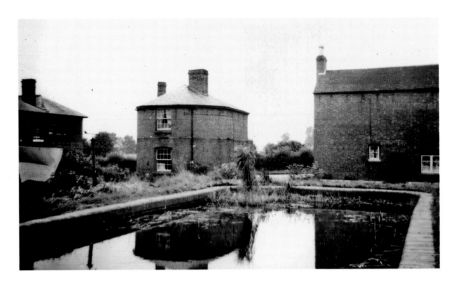

Worcester & Birmingham Canal, Hanbury Wharf and Robins Survey 1826

Hanbury was the nearest wharf to Droitwich and the saltworks there. Salt was conveyed along the turnpike from the works and the coal required for the evaporating pans was sent in the opposite direction. There was also a trade in lime from Shelve lime kilns, 2 miles distant. Hanbury Wharf was at first simply a wharf on the offside of the canal, but in January 1834 traders based at the wharf requested better facilities there. A long, wide basin was cut through the wharf site in order to aid trans-shipment of salt and coal and reduce the amount of boats moored alongside the main waterway. Plans were also considered for a railway from the wharf. This scheme did not go ahead, and later a canal was made to link Hanbury with the existing Barge Canal. William Robins surveyed canal features alongside the Worcester & Birmingham Canal. His drawing (*below*) shows William Tredwell occupying a large part of the wharf (*A*) and saltmaker Farndon, a smaller area (*B*). *RCHS Hugh Compton Collection 65991; Birmingham Library Archives 842801.*

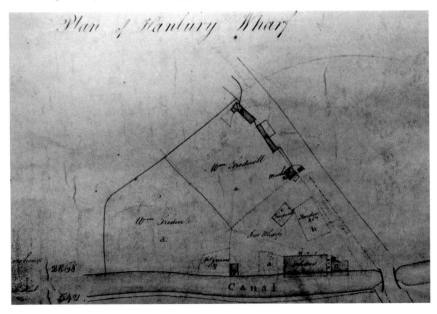

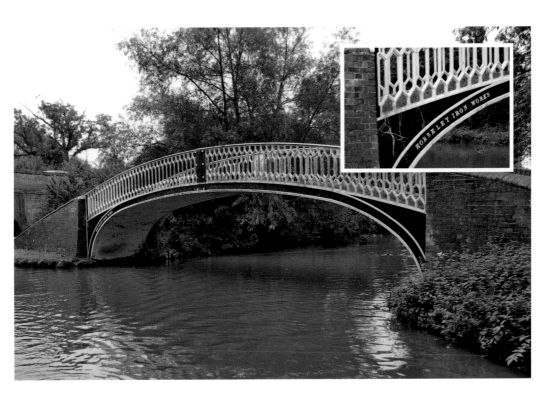

Oxford Canal, Newbold, Bridge 45, Horseley Iron Company and Brinklow Arches
The straightening of the Oxford Canal led to a widening of the existing embankment and aqueduct at Brinklow. One arch remained to carry the Smite Brook under the canal. The lower image shows the arch in detail. *Ray Shill.*

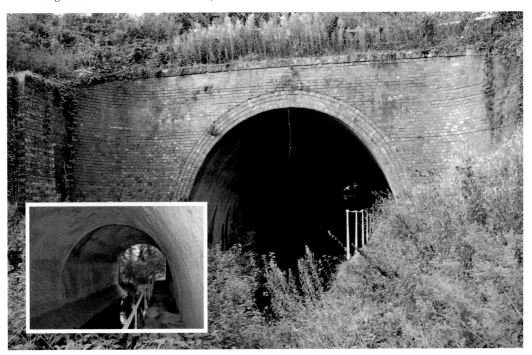

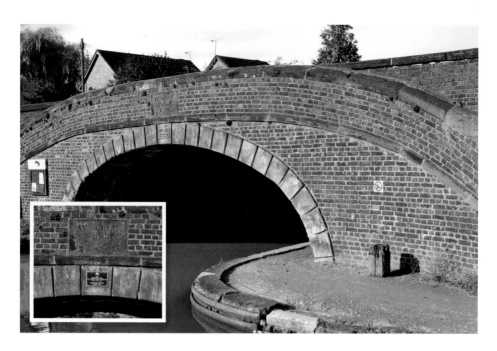

Trent & Mersey Canal, Lock 66, Wheelock and Wardle Canal
The Cheshire and Staffordshire locks that descend from the summit level towards Middlewich were duplicated under the direction of Thomas Telford in order to speed up transit of goods to and from the Potteries. The stone and brickwork detail of the lock bridge and lock chamber are evident in this view (*above*), seen from the rear of a boat entering the east side lock. The short link of 1829 known as the Wardle Canal (*below*) provided the important link between the Trent & Mersey Canal at Middlewich and the Ellesmere & Chester Canal Company (Middlewich Branch). The entrance to the link is spanned by an ornate stone and brick towpath bridge. *Ray Shill.*

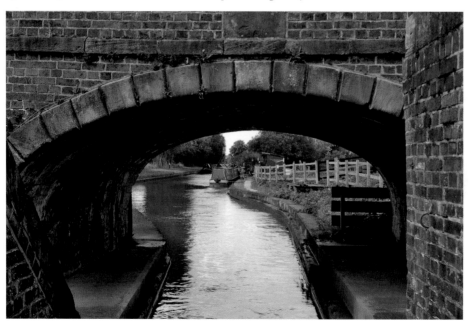

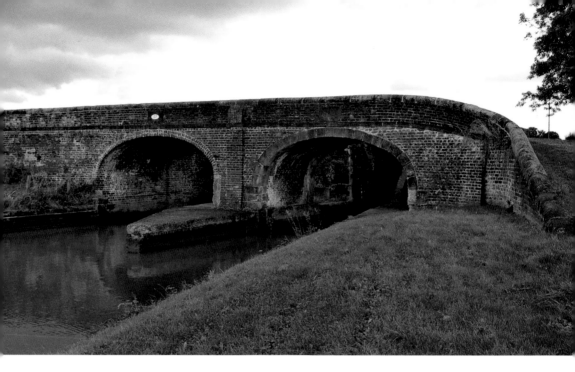

Trent & Mersey Canal, Bridge B7 at Lawton Treble Locks and Pool Stock Aqueduct
The double bridge across the tail of the lock (*above*) shows evidence of two periods of construction, the original (*left*) was built during the period the canal was first constructed (1767/77), and the second (*right*) during the additional lock building program conducted under Telford (1830s). The theme of the stone-faced arch, common on the bridges, was replicated on this aqueduct (*below*), which carries the Hall Green Branch over the canal. *Ray Shill.*

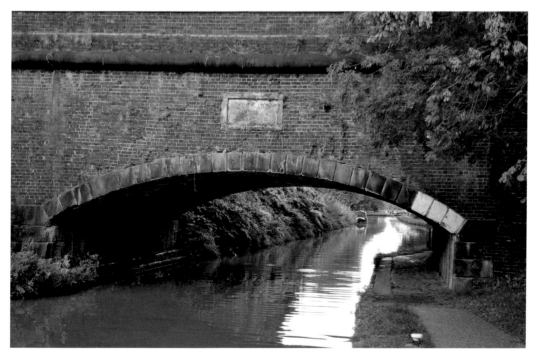

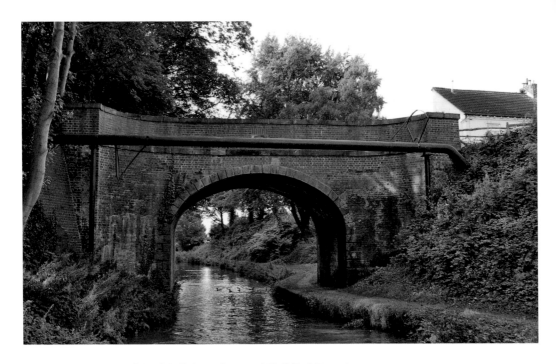

Trent & Mersey Canal, Red Bull Aqueduct and Hall End Branch
The precision-made stone and brick Red Bull aqueduct, seen below, is testament to Telford's skill as an engineer. The short Hall End Branch (*above*) is also rich in engineering features, including the two aqueducts and a brick overbridge. Again, the careful attention to detail can be seen in the precise lines and stone on the arch of the overbridge. *Ray Shill.*

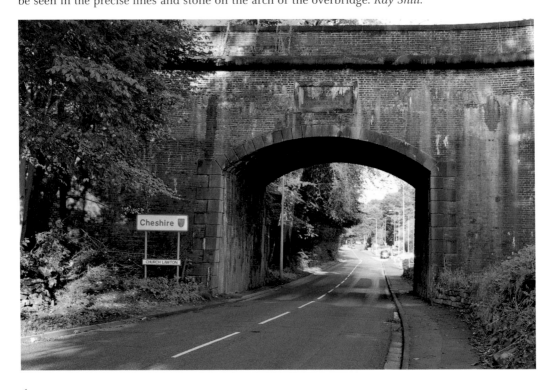

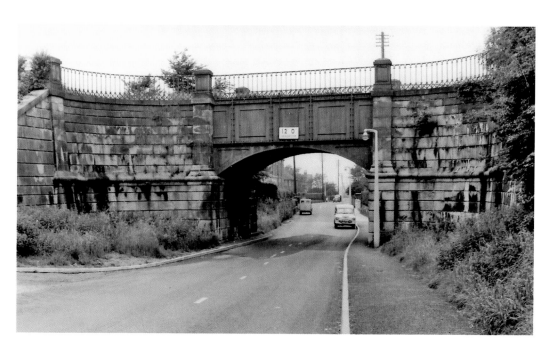

Macclesfield Canal, Congleton and Congleton Aqueduct, 1958

On the approach to Congleton from the south the first structure encountered is the turnover bridge that diverts the towpath to the opposite bank and away from the wharf and warehouse on the north bank. The Macclesfield is noted for some fine masonry aqueducts, but at Congleton there are two with an iron trough. The aqueduct south of Congleton near the wharf (*above*) is clearly made to a degree of elegance. North of Congleton the canal is carried across the Biddulph Railway (*below*), where the exterior is masonry but the interior is one of an iron trough. *Photographer P. J. Norton 65112; RCHS Hugh Compton Collection; Ray Shill.*

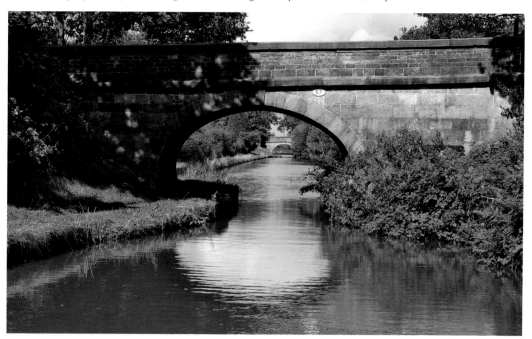

Macclesfield Canal, Dane Aqueduct, 1955 and Bosley Locks, The canal crosses the valley of the River Dane on a tall aqueduct (*above*), before the ascent through Bosley Locks to the summit length. This tall, stone structure remains a credit to the contractors who built it. While the locks were carefully placed and restricted to one place, Bosley, extensive engineering was required in places to maintain the level. At Bosley the arrangement of gates is unusual, with mitres at both the bottom and top, as shown below. Shown inset is bridge 56 at Bosley Locks. All bridges placed along the Macclesfield have a certain element of the artistic. *RCHS Hugh Compton Collection 65126; Ray Shill (above & inset).*

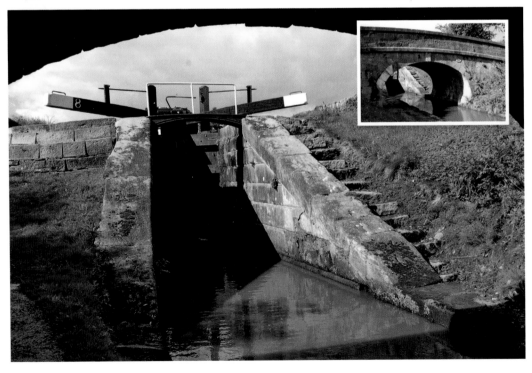

Birmingham & Liverpool Junction Canal, Norbury Junction and Lock House, Audlem
Norbury was the junction between the mainline from Wolverhampton to Nantwich and the branch to Newport and Wappenshall. The canal company workshops were located here and it was here that the BLJC steam tugs were maintained. The strategic placing of locks into groups on the Birmingham & Liverpool Junction Canal proved to be an asset for carriers, as the alternative of distributed locks, common on other waterways, could hinder traffic. The longest flight of locks was placed at Audlem (*below*). *Ray Shill.*

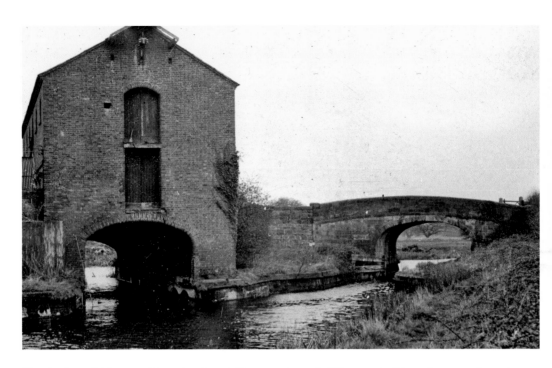

Birmingham & Liverpool Junction Canal, Newport Branch, Wappenshall Junction, *c.* 1962 and Forton Aqueduct

Wappenshall Warehouses were placed at the junction between the Shrewsbury Canal and the Newport Branch. One warehouse was built over a through-basin link. The Newport Branch was completed in 1835 and enabled narrowboats to reach Shrewsbury. The Newport Branch provided the link between the Main Line at Norbury and the Shrewsbury Canal at Norbury. After a steep descent from Norbury the canal then had an easier level to follow to Forton (*below*). *RCHS Transparency Collection 75110; Ray Shill.*

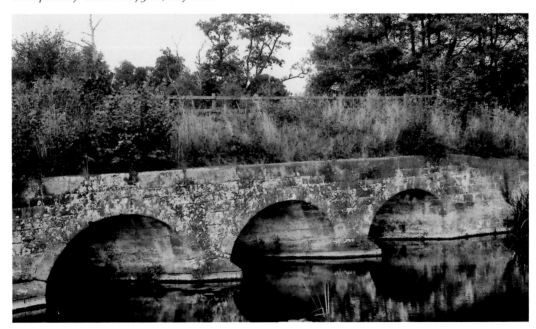

Hereford & Gloucester Canal, Hereford Basin, 1957
The Hereford & Gloucester Canal was completed from Ledbury to Hereford during 1845, but only enjoyed forty years of traffic before its closure. When the Hereford & Gloucester Canal was replaced by a railway built along part of the route, what was left had little use, although sections retained water. This view of partly infilled terminus basin section is on a section in Hereford. *RCHS Hugh Compton Collection, Photographer Charles Hadfield 64825.*

chapter five
The Railway Era

BCN Tame Valley Canal, BCN Rushall Canal, BCN Netherton Tunnel, BCN Cannock Extension,
BCN Wyrley Bank

The adaptation of the skills used in designing and building canal infrastructure for the making of railways also encouraged improved methods in canal construction. Both also benefitted from improved methods in manufacturing. Wrought iron and steel became more readily available, and brickmaking vastly improved during this period as a result of mechanisation and better kiln design.

This coincided with the West Midland canal mergers of the Birmingham, Dudley and Wyrley & Essington Canals, the development of a new coalfield on Cannock Chase and a dramatic rise in iron production throughout East Worcestershire and South Staffordshire.

The enlarged Birmingham Canal system continued to expand through the making of new and crucial industrial links. These included the Tame Valley, which was of principal benefit to the developing South Staffordshire wrought-iron trade; the Netherton Tunnel and Two Lock Line that were associated with the railway interchange trade; and the Rushall, Cannock Extension and Wyrley Bank Canals that served new colliery developments on Cannock Chase.

Other canal schemes were the Stourbridge Extension Canal that was made from the Stourbridge Canal at the Lays to Shut End to serve ironworks and brickyards, and the completion of the Hereford & Gloucester Canal from Ledbury to Hereford.

This was also a time when railway companies purchased canals, partly to assist route expansion and partly to reduce competition. The Trent & Mersey Canal was acquired by the North Staffordshire Railway Company as part of its incorporation arrangements. Thus it became a canal carrier, at least until their core railway system was completed; then it handed over the carrying trade to the Duke of Bridgewater's trustees as agents. They in turn arranged improved warehouse facilities, which were of benefit to the salt and pottery trades. Maintenance and improvements remained the responsibility of the rail company. Other railway company acquisitions included the Stratford-Upon-Avon Canal, Stourbridge Extension Canal and Upper Avon Navigation, all of which passed to the Oxford, Worcester & Wolverhampton Railway Company but later came to be owned by the Great Western Railway Company.

A feature of the railway age was that certain railway companies promoted rail and canal interchanges. A brief, early trade was between the Shrewsbury & Birmingham Railway and the GWR near Banbury. Such long-distance services were, however, limited and the core business was specific and local. Railway interchange basins were concentrated in the West Midlands, where trade from chain works, factories, furnaces and ironworks contributed to a busy traffic both ways between canal and railway. Railway construction also created a new canalside infrastructure where bridge and viaducts spanned the waterway or new aqueducts were constructed to carry the waterway over railway tracks.

Stourbridge Extension Canal, Brockamoor and Birmingham & Warwick Junction Canal, Stop Lock

The short Stourbridge Extension (*above*) was built to serve collieries, iron furnaces and firebrick works. The canal was purchased by the Oxford, Worcester & Wolverhampton Railway, which used the route to construct a parallel railway track (Kingswinford Branch). It ran from Shut End to the Stourbridge Canal (Fens Branch) at Brockamoor. The route was gradually cut back in the 1930s towards Brockamoor where there was a railway interchange. In the centre of this view a guillotine gate stop lock can be seen, which then became the effective 'limit' of navigation. The Weaver image below appears to have been taken from the Gravelly Hill Interchange before it was opened. From this viewpoint the route of the Birmingham & Warwick Junction is seen in the centre of the picture and Nechells B Power Station to the left. *RCHS Weaver Collection 48067, 45601.*

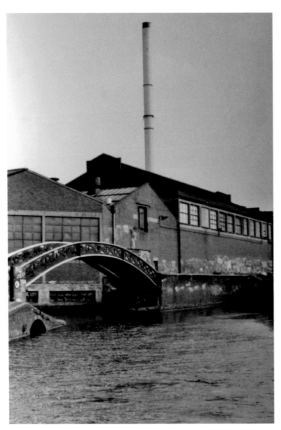

Birmingham & Warwick Junction Canal, Junction, Bordesley and Birmingham Canal Navigations, New Main Line and Skew Railway Bridge

To the right of the picture (*left*) is the start of the Camp Hill flight of locks, which rise through six locks to the summit level of the canal. The towpath bridge crosses the junction with the Birmingham & Warwick Junction Canal, which linked the Birmingham & Fazeley and Tame Valley Canals with the Warwick & Birmingham. This short waterway was completed in 1844. Below, the Birmingham, Wolverhampton & Stour Valley Railway crossed over the New Main Line near the Soho Foundry by a brick and stone skew bridge, which comprised two arches. The iron braces are testament to the age of the structure. Less obvious are the scorch marks caused during the Second World War, where some suggest a boat caught fire during an incendiary bomb attack. This side of the bridge is contemporary with the opening of the railway in 1852. *Ray Shill.*

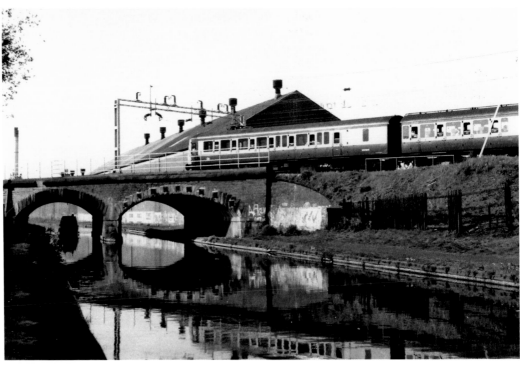

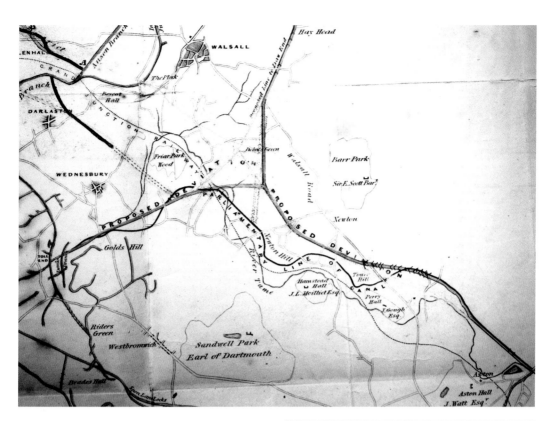

Birmingham Canal Navigations, Tame Valley Canal and Route Not Adopted

The Tame Valley Canal as authorised by Parliament followed the contours of the Tame Valley and River Tame. James Walker and William Fowler saw this design as a backward step in view of the recent cutting of the New Main Line. They resurveyed the route and incorporated a link to meet up with the Hay Head Branch near Aldridge. They came up with three alternatives for a straighter route. The final course adopted is that marked 'proposed deviation' on the above map. Another option suggested was a 'crossroads' at Delves Green (*right*). In this version a level junction was suggested there, with the bottom left-hand canal continuing to Wednesbury, the top left-hand canal heading to meet up with the Walsall Canal near the Pleck, and the top right-hand canal joining the Hay Head Branch near Longwood. *Ray Shill.*

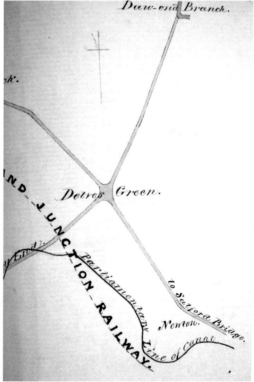

71

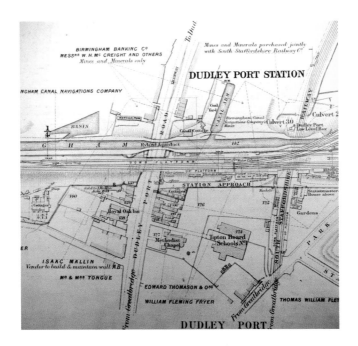

Aqueducts at Dudley Port and Tame Valley

Dudley Port (*above*) is a section of road and the area where both the New and Old Birmingham Canals crossed it. The New Main Line passed over Dudley Port by the brick-built Ryland Aqueduct, having been carried across the Sheepwash Valley by a long embankment. It was carried as far as Park Lane, where a second brick aqueduct carried it to the high ground nearby. The first railway route through Dudley Port was the South Staffordshire Railway (opened in 1850), which passed under the BCN Main Line and required an aqueduct to be made at this point. Surrounded by pipes, railings and pylons, the Tame Valley Canal (*below*) crosses the river Tame at Bustleholme by a tall, single-arch aqueduct that does the engineer and his team credit. *Inset*: The Tame Valley Canal crossed the Walsall turnpike road near Tame Bridge. *Ray Shill.*

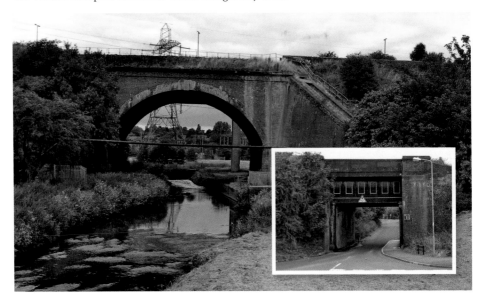

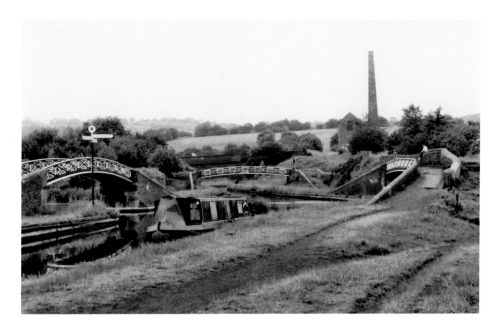

Dudley Canal, Windmill End Junction and Brewin's Tunnel

Here at Windmill End (*above*) the original route of the Dudley No. 2 Canal passed from left to right, while the new line from the tunnel, built in 1858, is seen in the centre of the picture. Brewin's Tunnel (*below*) was cut under the hill when the original winding route was covered by Lodge Farm Reservoir. The tunnel had only a short period as a covered piece of canal. The improvement works of 1857/58 included the opening out of the tunnel. The road was carried across the deep cutting by a brick bridge. George Meakin, the builder of Netherton Tunnel, was also the contractor for this work. In this early 1900s view, the west side of the tunnel is seen, as well as the towpath bridge that spanned the entrance to Doulton's clay basin. *Ray Shill; Heartland Press Collection 635324.*

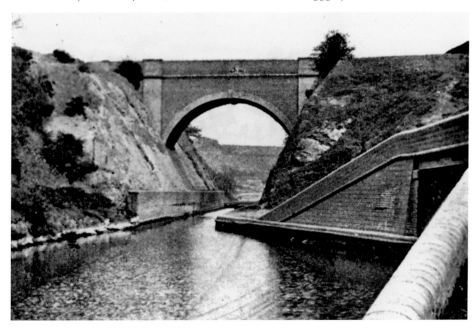

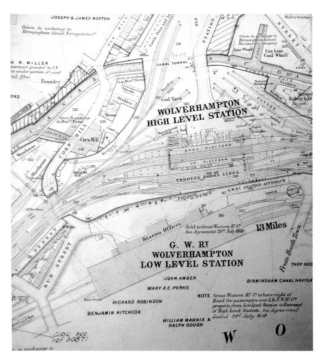

Wolverhampton, London & North Western Railway Plan and Horseley Fields

Left: The canal at Wolverhampton was diverted when the High Level was constructed. The original route was covered over by the higher structure, leaving a short length to serve Norton's Mill. The wharves later developed as the Shropshire Union Depot. *Below*: The Stour Valley Railway was carried on a series of arches, while the Birmingham, Wolverhampton & Dudley Railway was brought under the Wyrley & Essington Canal in a tunnel. The Wyrley & Essington Canal route is to the left of this map section and the former stop lock, overflow channel and towpath toll-house are all evident. *Heartland Press Collection 214010, 214011.*

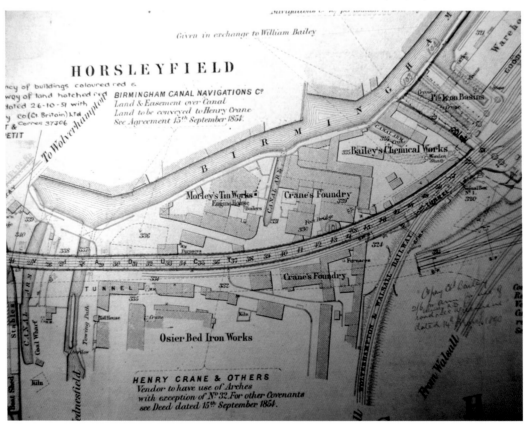

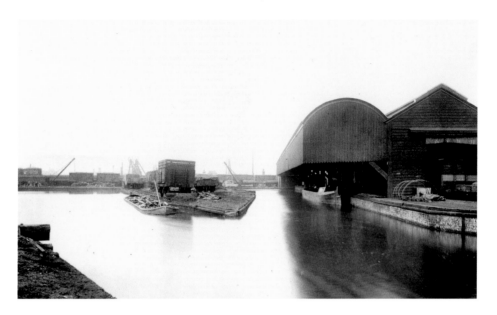

Birmingham Canal Navigations, LNWR Bloomfield Interchange Basin and Warwick and Napton Canal, Birmingham & Oxford Junction Railway Aqueduct

West Midland canals had number of railway interchange basins where traffic was transferred between canal and railway. Isambard Kingdom Brunel was the engineer in charge of the Great Western Railway and many of their acquisitions. The Birmingham & Oxford Junction Railway (*below*) formed part of the GWR route into Birmingham and Brunel was responsible for designing the infrastructure for this route. This railway passed under the Warwick & Napton Canal south of Warwick and the canal was carried across the rails in an iron trough, although the facing and supports of the aqueduct were brick and stone. The generous width of the arches was to allow both broad gauge and standard gauge railways; the railway had three running lines for this purpose. *RCHS Print Collection 40889; RCHS Transparency Collection 57341.*

chapter six

River Improvement Schemes

Anderton Lift, Trent & Mersey, Widening Anderton–Middlewich, River Severn

Construction technology improved during the nineteenth century as contractors honed their skills building tramroads and railways. Such experience was translated into bigger projects that began with the making of locks on the Severn. Various schemes to improve navigation along the Severn had come and gone, but the essential 'free' navigation that traders enjoyed hampered commercial improvement. This state of affairs finally changed when William Cubbit designed a new type of lock and weir that was conceived on a grand scale. The new river locks constructed between Worcester and Stourport changed navigation on that part of the river and subsequent lock building at Upper Lode and Gloucester ensured that larger craft could navigate the river where the previous limit had been the trow and barge.

Long after the railway network was established in Britain, technical innovation continued to help the development and, in certain cases, competiveness of the waterways. In the seemingly unfair struggle for trade with the railways the waterways continued to capture certain and specific markets. Carriage of coal by water was still popular in the North East, North West and West Midlands. Competition with rail was particularly keen for the waterways that stayed in private ownership. The introduction of mechanical traction led to the increasing use of steam haulage, frequently with tugs but in other cases steam-powered carrying craft, on rivers and canals.

Navigation owners also looked abroad for inspiration and for a time waterway development in Europe encouraged British canal companies to strive for expansion and finance new infrastructure. Yet while European Waterways continued to improve, few British Waterways were willing to invest in similar ventures, although those that did utilised a characteristic of the British – innovation and invention.

It is a small list, but included in this period is the Anderton Boat Lift in Cheshire, which created for the first time a means for boats to pass between the Weaver and the Trent & Mersey, a development that favoured the transport of salt and pottery goods and associated raw material for the pottery trade. To assist the transport of salt the canal was widened from Anderton to Middlewich so that, in addition to the traditional narrowboat, Weaver Flats might pass this far, in order to serve a number of saltworks that lay on that section of waterway. Another was the Foxton Incline Plane, which was intended to assist the busy Foxton Locks, then a major bottleneck to trade. The plane had the advantage of being able to carry Trent Boats or a pair of narrowboats. Unfortunately the Old Union was only capable of passing narrowboats and the lift usage was light.

Steam engine refinements led to new pumping engines being installed at strategic parts of the network. G. R. Jebb, engineer to the BCN, chose to use efficient compound engines for new pumping plants at Parkhead and Smethwick.

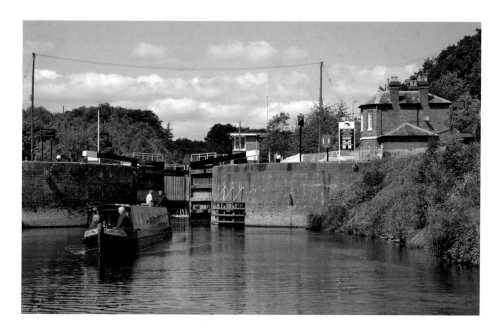

Holt Fleet Lock and River Severn, Bevere Occupation Bridge

The River Severn had natural navigation northwards as far as Pool Quay near Welshpool. Part of it was tidal and deeper water extended as far as Worcester. Further north this navigation was limited by water levels and craft could only pass through on the 'springs'. While schemes were proposed at different times to improve navigation, locks only came to be constructed during the period 1843–1845 and this improvement was restricted at first to the section from Stourport to Worcester, with the construction of four locks (Lincombe, Holt Fleet, Bevere and Diglis). An iron occupation bridge crosses over weir stream at Bevere Lock (*below*). This bridge was rendered necessary with the construction of the lock and lock channel, which led to the isolation of a piece of farm pasture. The substantial iron structure was perhaps an extravagant choice. *Ray Shill.*

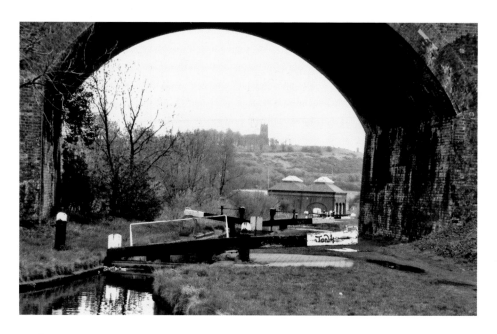

Dudley Canal, Parkhead Locks and Blowers Green Pumping Station and Birmingham Canal Navigations, Walsall Locks

G. R. Jebb, BCN engineer, brought the water supply for the Birmingham Canal network into the twentieth century with the construction of new pumping stations at Parkhead and Smethwick. The new engine house at Parkhead (*above*) was commissioned in 1892 and the engines (supplied by Hathorn Davey) had the capacity to recirculate water between the 442-foot, 453-foot and 473-foot levels of that system. The firm of James Watt & Co. provided triple-expansion pumping engines for the Walsall Pumping Station (*below*) to replace the existing engines there in 1899. These engines recirculated water from the 406-foot level to the 473-foot level. They were produced at the Soho Foundry after this famous firm had been purchased by Avery. *Ray Shill; Heartland Press Collection 649502.*

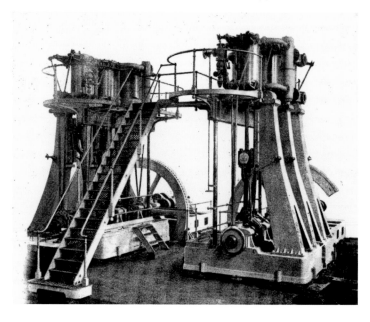

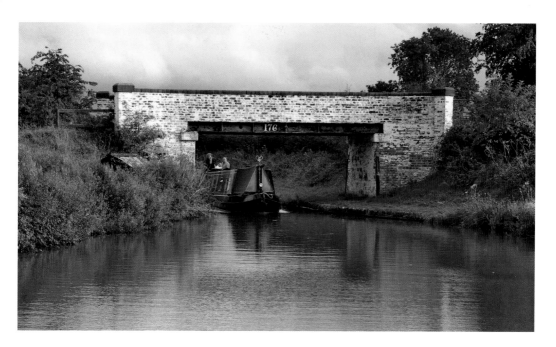

Trent & Mersey Canal, Bridge 176 and River Weaver Navigation, Anderton Lift, 1956
The section of the Trent and Mersey Canal from Anderton to Middlewich was widened in anticipation of barge traffic from the River Weaver travelling via the Anderton Lift. Such work also included the reconstruction of bridges. Those on this section have increased headroom through the provision of a metal deck. Anderton (*below*) became an important trans-shipment point between the Weaver and Trent Navigations, where salt was sent down chutes to flats on the river. The building of the lift enabled craft, notably narrowboats, to work through to the Weaver. Initially the lift was worked by hydraulic power, but salt in the river gradually corroded this mechanism and it was decided to convert the lift to electric traction. *Ray Shill; RCHS Collection 65784.*

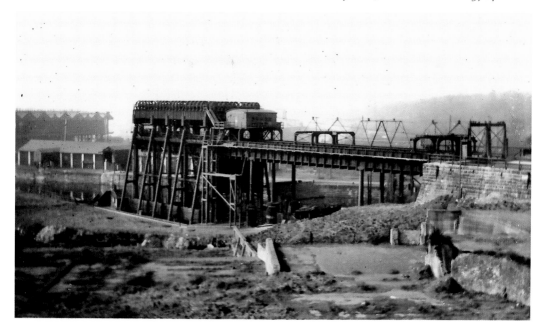

Twentieth-Century Navigations

Coal drops on the Canal, Electric Tug Haulage at Harecastle, Grand Union Canal

Canals continued to change as the new century approached. Labour-saving devices were invented and electrical plants became more common. Experiments with haulage in vessels powered by electric motors were tried on the Staffordshire & Worcestershire Canal near Kidderminster and Telford's Harecastle Tunnel came to have an electric tunnel tug. The Anderton Lift, which previously had been raised and lowered by hydraulic power, was converted to electric haulage.

This was also a time of canal closures and abandonment, for the railway-owned waterways in particular. The London & North Eastern Railway obtained powers to abandon the Nottingham Canal between Lenton and the Cromford Canal as well as the whole length of the Grantham, maintaining this canal only as supply of water at the request of the Farmer's Union.

The London, Midland & Scottish Railway abandoned sections of the Shropshire Union Canal, principally on the lines to Shrewsbury and Newtown. Sections of the canal in Shrewsbury and parts near Trench were officially abandoned, and then with the Act of 1944, larger sections, including the East & West Montgomery Canals, were abandoned. These sections had effectively been closed with the breach in the canal. The Great Western Railway also took the opportunity to close the Southern Stratford and abandoned most of the length of the Stourbridge Extension Canal.

Independent canal companies also closed parts of their system. The Staffordshire & Worcestershire Canal ceased to use the Sow Link into Stafford. The Derby Canal ceased to use the branch to Little Eaton and the Worcester & Birmingham closed the Droitwich and Droitwich Junction Canals.

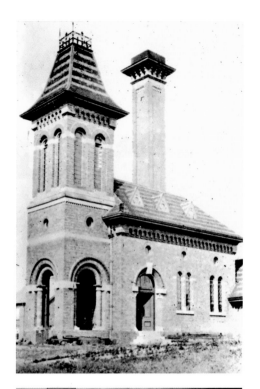

Birmingham Canal Navigations, Tame Valley Canal, Perry Well Pumping Station

The Birmingham Canal Navigations made improvements to their pumping plant from time to time. New pumping stations were erected at Parkhead and Smethwick and more efficient engines installed at existing stations. All such improvements were made during the lengthy stewardship of G. R. Jebb as company engineer. The pumping station at Perry Well was purchased from Birmingham Corporation which had acquired it from the Birmingham Waterworks Company to supply the City of Birmingham during Joseph Chamberlain's campaign to improve public services. With the inception of the water supply from Elan Valley this supply had become surplus to requirements. The BCN only used the engine for a few years (1906–1913) and when the supply was terminated this pumping station was demolished. *RCHS Weaver Collection 45955, 45956.*

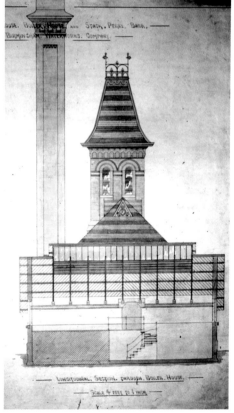

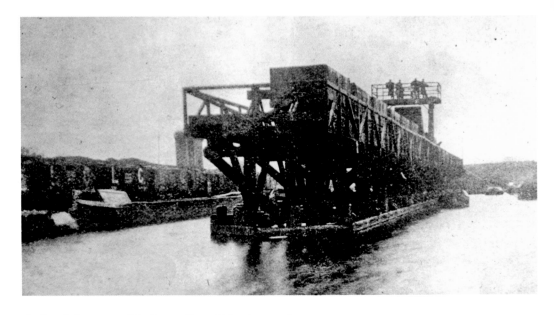

Coal at Otherton and Railways Near Aldersley, 1916

The Staffordshire & Worcestershire Canal skirted the South Staffordshire Coalfield. There was a basin at Otherton (*above*) that served initially to supply materials for the sinking at the Cannock & Huntingdon Colliery. While this venture failed, another sinking project by the Littleton Colliery Company succeeded. From 1902, a standard gauge private railway brought coal down to a much-enlarged basin where trucks could unload into boats waiting alongside the wharf by chutes from an overhead staithe. Railways continued to be constructed into the twentieth century. One late scheme was the GWR line from Wolverhampton to Kingswinford to join up with the existing branch from Brierley Hill. Work started in 1914 but construction was halted during the First World War. Much of the infrastructure had been completed and this brick bridge over the canal near Aldersley (*below*) was partially in operation, taking hospital trains carrying soldiers to Tettenhall. The GWR finally completed the railway in 1925. *RCHS Weaver Collection 48025; Heartland Press Collection 891205.*

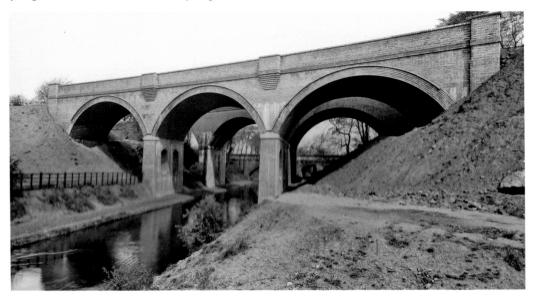

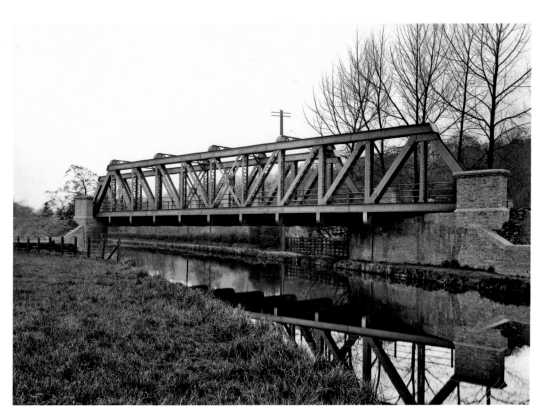

Staffordshire & Worcestershire Canal, 1916 and Trent & Mersey Canal, LMS Electric Tug at Harecastle New Tunnel, Trentham *Above*: The 'Meccano Bridge' near Tettenhall was constructed on a skew, with steel girders to span the canal. *Below*: Electric haulage was introduced to speed up movement through Telford's Harecastle Tunnel when the old Brindley Tunnel became disused. A battery-powered craft was replaced by an overhead electric system. The tug would haul a train of boats through before returning with craft from the other end. *Heartland Press Collection 891081, 65818.*

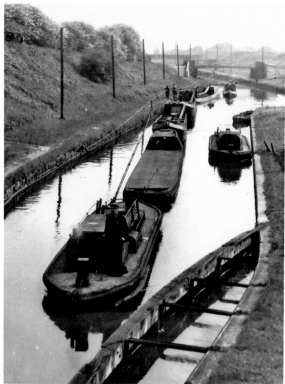

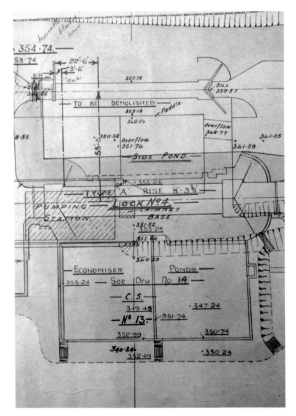

Grand Union Canal, Knowle Locks

Six narrow locks at Knowle were reconstructed as five barge locks complete with new concrete-lined economiser ponds. Lock 4 in the original flight had a pumping engine house which was completely removed with the reconstruction work, which took place in 1933/34. Below is Knowle Locks as seen on a summer Sunday in June 2010. The economiser ponds are located to the left and the close-cut grass is testament to British Waterway's regular attention. *Ray Shill.*

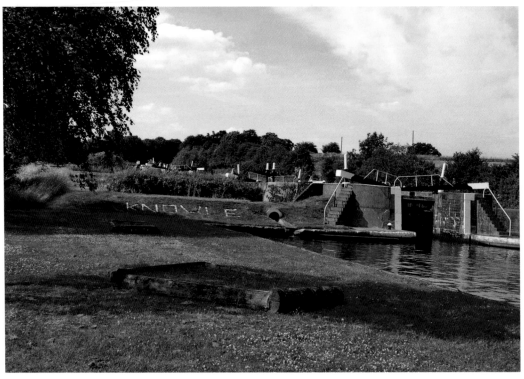

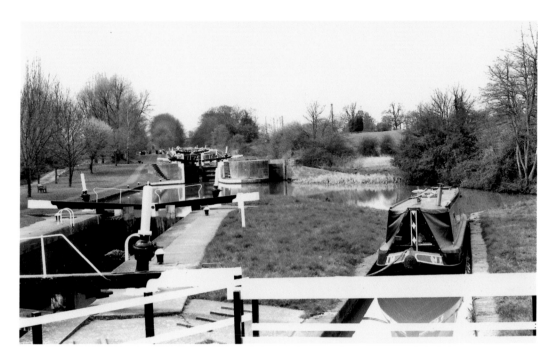

Grand Union Canal, Hatton Locks and Knowle Locks

Hatton locks (*above*) comprised in total twenty-one locks prior to and after the reconstruction made between 1931 and 1934. The new locks crossed from one side to the other of the original flight. Some of the old chambers were removed in the process, but most were retained as overflow weirs. With the widening of the locks at Knowle and Hatton and to Napton, most narrow locks were retained as weirs. Below, an old lock chamber at Knowle Locks is seen. *Ray Shill.*

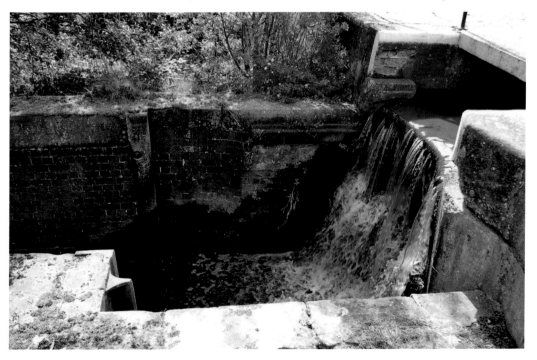

Nationalisation, Restoration and Trusts

Docks & Inland Waterways Executive, British Waterways (canal closures), Stourbridge Canal (restoration), Stratford-Upon-Avon Canal (restoration) Lichfield & Hatherton Trust, Droitwich Canals, Lower and Upper Avon (restoration), Canal & River Trust

The creation of the Docks & Inland Waterways Executive (DIWE) was a result of the 1948 Transport Act. This executive first took over many of the independent waterways and then set about merging these with the canals acquired by the Railway Executive. Canals and River Navigations that remained outside this arrangement were the Charnwood Forest Canal (derelict), Derby Canal, Droitwich canals (derelict), Leominster Canal (derelict), Lower Avon Navigation, Nutbrook Canal, Oakham Canal (derelict), Sir Nigel Gresley's Canal (derelict), Upper Avon Navigation (derelict), Uttoxeter Canal (derelict) & Wreak Navigation (derelict).

Under the 1954 Transport Act, British Waterways, successor to the DIWE, arranged for closure of several disused canals. Lost at this time was the section of the Wyrley & Essington Canal between Brownhills and Huddlesford, part of which was sold off to private landowners during the 1960s and 1970s. A policy of closure continued, but there was a growing force of dedicated boaters keen to keep as much of remaining network open as possible, as the declining commercial traffic was counterbalanced by the increasing pleasure boat trade.

The restoration spirit began with the efforts of the NCC (North Cheshire Cruising Club); their efforts to keep the Macclesfield open must be seen as crucial step in this regard. In the Midlands an early battleground was the Stourbridge Canal, and restoration work here helped to convince a government minister, Barbara Castle, of the future of inland navigation. The creation of the cruiseway helped to establish a new national network of waterways; that for the boater.

A growing band of supporters pressed on with other restorations across the country, mainly using volunteer labour. The first midland canal to be restored to the network was the Southern Stratford-Upon-Avon. This was followed by the Upper Avon Navigation, Caldon, Cromford, the Droitwich Canals, Dudley Tunnel, Grantham and the Titford Canal. Supporters also led a Coventry Canal clean-up campaign in 1971 to prevent the decay of the navigation from Hawkesbury to Coventry basin. Increased use by boaters kept other key navigations open, such as the Birmingham & Fazeley, Grand Union, Shropshire Union, Staffordshire & Worcestershire, Trent & Mersey and Worcestershire & Birmingham.

There were some failures. Attempts to save the Shrewsbury Canal and the link to Norbury Junction proved unsuccessful. This waterway had suffered from poor trading since the days of the LMS railway, but now the whole length was shut and parts disposed of.

State-owned waterways came under the jurisdiction of British Waterways in 1963. They have continued to manage the network, but from June 2012 waterways in England and Wales passes to the Canal & River Trust. Some issues as to responsibility may have to be resolved, such as the current commitment to the Grantham Canal and the question of the reservoirs that formerly served canals. Trench Reservoir by the former Trench Incline is a case where British Waterways currently maintains the reservoir despite all traces of the waterway it supplied being removed.

The sole independent undertaking is the navigation of the Warwickshire Avon from Tewkesbury to Stratford, which is now the combined Lower and Upper Navigation Trust. Restoration schemes elsewhere include the Hereford & Gloucester and the Lichfield & Hatherton Trusts, which will remain outside the CRT once navigation is restored.

Birmingham Canal Navigations, Walsall Canal, Grand Junction Railway Aqueduct and Trent & Mersey Canal, Thurlwood Steel Lock

The railways electrification program, between 1958 and 1967, was centred on the West Coast Main Line and various lines in Birmingham and the Black Country. It included the freight and diversion route from Bescot to Wolverhampton and in particular was to affect the Walsall Canal aqueduct over the railway. It was partly reconstructed in concrete during 1964 (*above*). Subsidence through salt extraction damaged part of the Trent & Mersey Canal, and led to levels being raised by the North Staffordshire Railway, the LMS and even British Waterways. Improvements included the new Thurlwood Steel Lock. Operating this lock and the guillotine gates at either end required a unique procedure, which is set out on instruction boards. Such an arrangement proved complex for some boat operators who frequently chose to use the adjacent conventional, lock. *RCHS Weaver Collection 45507; RCHS Transparency Collection 76361.*

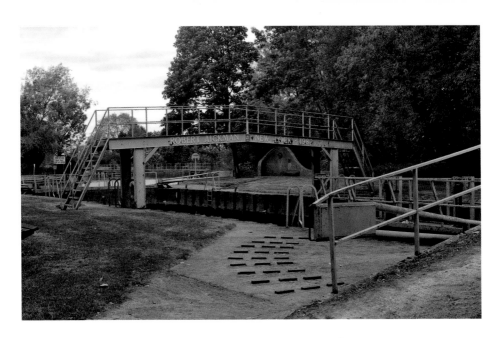

River Avon, Robert Aickman Lock, Harvington and Wyre Lock

Above: The restoration of the Upper Avon began on the section from Harvington to Evesham in 1969 and worked northwards towards Stratford-Upon-Avon culminating with the reopening of the navigation in 1974. The original lock at Harvington was restored, but it was subsequently decided to improve the navigation at this point through the construction of a new channel that utilised, in part, the mill stream. A new lock was created in 1982, while the first restored lock was adapted to serve as a dry dock. *Below*: When the Lower Avon was restored, the diamond-shaped lock at Wyre was retained for the navigation and repaired to retain the original form. This type of lock is attributed to the early time of the navigation and William Sandys, who was responsible for making this part of the Avon navigable. *Ray Shill.*

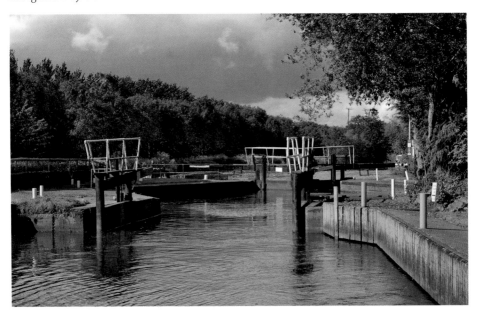

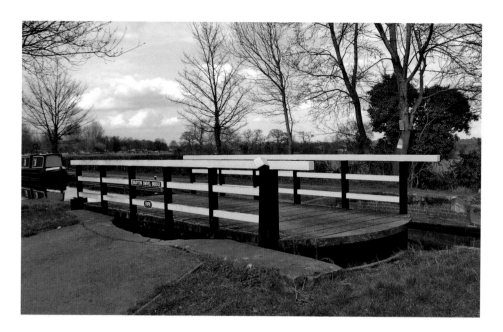

Birmingham & Fazeley Canal, Drayton Swivel Bridge and Salford Junction

The Birmingham & Fazeley Canal formed part of the Birmingham Canal Navigations Network of waterways. During the early period of this canal's operation through the industrial heartland of South Staffordshire a few swivel or swing Bridges were provided where practical, but as trade increased the use of such bridges was restricted and brick bridges came to replace them. With the Birmingham & Fazeley those sections in the rural areas also had swivel bridges for farm accommodation use. Such structures were made of wood. British Waterways inherited the Drayton swivel bridge and when the repair became uneconomic a new metal swivel was provided (*above*). The construction of the Gravelly Hill Interchange on the M6 Motorway required a temporary stoppage at Salford Bridge (*below*). *Ray Shill; RCHS Weaver Collection 45461.*

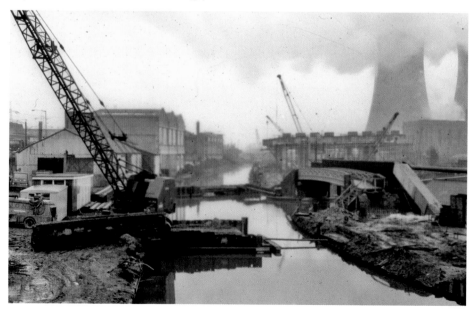

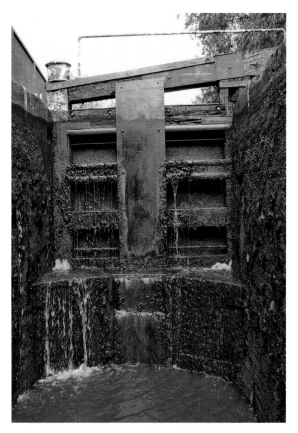

Worcester & Birmingham Canal, Upper Lock Gate, Worcester and River Weaver, Anderton Lift
Above: British Waterways have restored heritage features with a keen desire to replicate original design. The Worcester & Birmingham lock gates possessed a post (or bollard) around which the steerer looped the stern rope as the boat entered the lock, the motion of the narrowboat closed the gate behind it as the boat itself was brought to a stop when the gate closed. *Below and inset*: the Anderton Lift was restored and is now in its third stage of operation. *Ray Shill.*

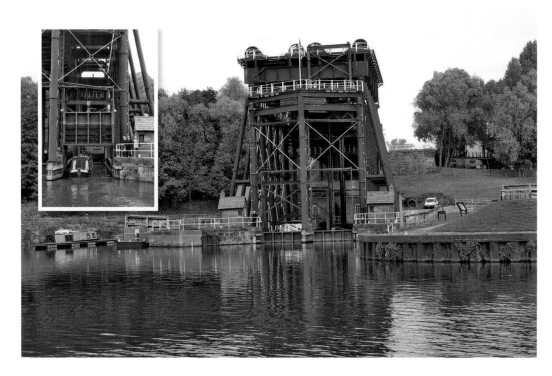

Trent & Mersey Canal, Dane Aqueduct Near Middlewich
The Trent & Mersey Canal was at first carried over the Dane by a narrowboat-width aqueduct. This structure was replaced by a barge-width aqueduct, but following flooding the structure was restored to its present narrowboat dimensions and comprises a steel trough, wooden-plank footway and steel railings. *Ray Shill.*

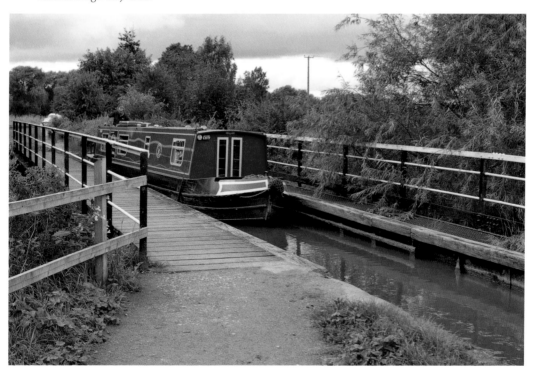

Restoration Schemes in the West Midlands

Hereford & Gloucester Canal Trust:
Restoration has begun on parts of the canal, and specifically at Over, where a junction will be made with the River Severn. The Trust also now own Llanthony Lock on the Severn and plans eventually to use this former barge lock to pass boats from the navigable Severn to Over.

Lapal Trust
Restoration of Dudley Canal from Selly Oak to Hawne Basin is planned. The original scheme to restore Lapal Tunnel was dropped in favour of constructing a flight of locks over the summit.

Lichfield & Hatherton Canals Trust
Restoration of two sections has been on-going since the 1990s: Staffordshire & Worcestershire Hatherton Branch and Wyrley & Essington Canal, Ogley–Huddersfield Junction.

Newport & Shrewsbury Canal Trust
Restoration of the navigation from Norbury Junction through to Shrewsbury is contemplated. The trust is now actively restoring the former warehouses and wharves at Wappenshall.

Stafford Riverway Link
Restoration of the Sow Navigation from Stafford to the Staffordshire & Worcestershire Canal.

Wappenshall Wharf, May 2012
Shrewsbury & Newport Canal Trust has begun restoration of Wappenshall Wharf and Basin, originally built for the Duke of Sutherland. The right-hand warehouse had a dock and cranes where goods from boats could be raised to the first floor for loading on to road wagons.

Notable Structures on Midland Navigable Waterways

Grid references for lock flights and tunnels West-to-East or North-to-South
Grid references for feeders reservoir dam to canal inflow

Birmingham & Liverpool Junction Canal
Main Line
Adderley Locks (N/S) SJ669397–SJ671393
Audlem Locks (N/S) SJ657439–SJ660414
Autherley Junction SJ903020
Belvide Reservoir Feeder SJ869105–SJ875105
Berrisford Road Aqueduct SJ685344
Brewood Wharf SJ878093
Bridge 39 SJ790242
Chillington Cutting (N/S) SJ886080–SJ891074
Chillington Wharf SJ891073
Cowley Tunnel (N/S) SJ824198–SJ825197
Double Culvert Bridge (40) SJ790246
Grub Street Cutting (N/S) SJ778254–SJ790240
Hack Green Locks SJ641486–SJ642483
Lapley Wood Cutting (N/S) SJ866119–SJ870114
Nantwich Aqueduct SJ643527
Narrows (Upper Hatton–Lower Hatton) SJ891052–SJ889049
Norbury Junction SJ793228
Pendeford Aqueduct SJ888037
Shebdon Embankment (W/E) SJ748267–SJ758262
Shelmore Embankment (N/S) SJ794227–SJ806215
Shushions Embankment (N/S) SJ847146–SJ851138
Shushions Iron Aqueduct SJ848145
Stretton Aqueduct SJ873107
Tern Aqueduct, Tyrley SJ685345
Tyrley Locks (N/S) SJ688330–SJ691324
Weaver Aqueduct SJ654443
Wheaton Aston Brook Aqueduct SJ849143
Wheaton Aston Lock SJ858126
Wrottesley Turnover Bridge SJ894027
Woodseaves Cutting SJ694320–SJ700302
Newport branch
Forton & Newport Locks (W/E) SJ772217–SJ793227
River Meese Aqueduct, Forton SJ756209
Overbridge, Norbury SJ790226
Wappenshall Wharf SJ663145

Birmingham Canal Navigations
Anglesey Branch
Brownhills Aqueduct SK053064
Cannock Chase Reservoir, E. Dam (N/S) SK041077–SK041073
Ansons Branch
M6 Motorway Tunnel (N/S) SJ993987–SJ990983

River Tame Aqueduct SO987980
Birchills Branch
Railway Aqueduct SK003000
Birmingham & Fazeley
Aston Locks (N/S) SP088895–SP077882
Bourne Brook Aqueduct, Fazeley SK203015
Curdworth Top Lock (site) SP185937
Curdworth New Top Lock SP183936
Curdworth Tunnel SP177932
Drayton Manor Footbridge SK200008
Drayton Manor Swivel Bridge SK200008
Farmer's Bridge Locks (N/S) SP067876–SP062870
Tame Aqueduct (Salford Bridge) SP096900
Digbeth Branch
Ashted Locks (N/S) SP079875–SP082872
Dudley Canal
Brewins Tunnel SO935876
Delph Locks (N/S) SO920867–SO917864
Dudley Tunnel (N/S) SO947917–SO933893
Gosty Hill Tunnel (N/S) SO964857–SO969854
Lapal Tunnel (W–E)
Gower Branch
Staircase Locks SO979903
Netherton Tunnel Branch
Netherton Tunnel (N/S) SO967908–SO954884
New Main Line
Dudley Road Skew Bridge SP047876
Galton Bridge SP014894
Rylands Aqueduct SO967917
Park Lane Aqueduct SO965919
SSR Aqueduct SO966918
Sheepwash Embankment (W/E) SO964919–SO980912
Smethwick Deep Cutting (W/E) SP000898–SP026890
Old Main Line
Edgbaston Reservoir Dam (N/S) SP046872–SP046868
Engine Arm Aqueduct SP024888
Groveland Aqueduct SO968909
Smethwick Locks SP024890–SP026892
Spon Lane Locks (W/E) SO997899–SP004898
Stewarts Aqueduct SP003897
Wolverhampton Locks SJ903012–SO917991
Rushall Canal
Locks (N/S) SP033962–SP039991
Tame Valley Canal
Crankhall Lane Bridge SP006944

Goldsgreen Aqueduct SO979936
Grand Junction Railway Aqueduct SP017948
Hateley Heath Aqueduct SO999943
Perry Barr Locks 1–11 (W–E) SP059927–SP077923
Perry Barr Locks 12 & 13 SP087907
Piercy Aqueduct SP048932
M5 Aqueduct SP020949
Newton Aqueduct SP024948
Newton Road Cutting (N/S) SP034943–SP037937
Spouthouse Lane Aqueduct SP045933
Tower Hill Cutting (W/E) SP054929–SP056927
Walsall Road Aqueduct SP016947

Titford Canal
Titford Locks (N/S) SO994893–SO994886

Walsall Canal
James Bridge Aqueduct SO989977
Ryders Green Locks (N/S) SO977927–SO985916
Tame Aqueduct (Great Bridge) SO977927

Walsall Locks Branch
Walsall Locks (N/S) SK004995–SK004986

Wyrley & Essington Canal
Birchills Junction SK003002
Bloxwich Aqueduct SK009005
Fosseway Lock (W/E) SK097077–SK101078
Horseleyfields Junction SO925986
New Cross Junction SO937998
Ogley Junction SK057060
Pipe Hill Embankment (W/E) SK085073–SK008077
Pelsall Junction SK019044
Sneyd Junction SJ984029

Birmingham & Warwick Junction
Garrison Locks (N/S) SP095879–SP092871
Tame Aqueduct SP097900

Coventry Canal
Atherstone Locks (N/S) SK290997–SK305975
Bedworth Cutting SP370866–SP365862
Coventry Basin SP334795
Fazeley Junction SK204020
Glascote Locks (N/S) SK217033–SK216032
Hartshill Depot SP328952
Hawkesbury Junction Bridge SP362846
Parrots Canal (N/S) SP364861–SP365851
Streethay Wharf SK147108
Tame Aqueduct (Fazeley) SK210023

Donnington Wood Canal
Hugh Bridge Incline Plane SJ740152
Pave Lane Wharves SJ759166

Droitwich Barge Canal
Hawford Junction SO843599
Locks 1–8 (W/E) SO844599–SO868612
Vines Park Basins SO897636

Droitwich Junction Canal
Lock at Vines Park, Netherwich SO903635
Locks 1–3 (W/E) SO918631–SO919630
New Staircase 4/5 SO904635
New Lock 6 SO904634
New Lock 7 SO906634

Hereford & Gloucester Canal
Ashperton Tunnel (N/S) SO650421–SO653418
Aylestone Hill Tunnel (N/S) SO516416–SO511415
Canon Frome Aqueduct SO633435
Ledbury Aqueduct SO702352
Newent Aqueduct SO714265
Staplow Aqueduct SO696414
Over Basin SO817918
Oxenhall Tunnel (N/S) SO705298–SO709277
Shelwick Aqueduct (River Lugg) SO533438
Skew Bridge, Monkhide SO612440

Ketley Canal
Ketley Incline Plane SJ678107

Leominster
Southnet Basin SO668704
Rea Aqueduct SO652703
Putnall Tunnel (N/S) SO502666–SO500662

Macclesfield Canal
Biddulph Railway Aqueduct SJ881626
Bollington Aqueduct SJ933779
Bosley Locks SJ908656–SJ906670
Congleton Aqueduct SJ867622
Dane Aqueduct SJ907653
Dane in Shaw Aqueduct SJ880625
Gurnett Aqueduct SJ926717
Grimshaw Lane Aqueduct (Bollington) SJ930774
Middlewood Aqueduct SJ952846

Newcastle-Under-Lyme Canal
Newcastle Basin SJ851455
Incline Plane to Junction Canal SJ855456

Newdigate Canals, Arbury
Double Lock SP335895
Junction with Coventry Canal SP366882
Six Locks & Aqueduct SP356883–SP357883
Triple Lock SP334895

Oxford Canal
Avon Aqueduct, Rugby SP515766
Braunston Wharf SP538657
Brinklow Arches SP443803
Brownsover Feeder SP508797–SP505790
Brownsover Arm (retained as feeder) SP505790–
 SP508772
Brinklow Arm (footbridge) SP448799
Brinklow Cutting SP444797–SP445794
Brinklow Embankment SP442804–SP443800
Fennis Fields Arm (footbridge) SP463785
Cathiron Cutting SP463784–SP465783
Hawkesbury Junction SP362845
Hillmorton Depot SP538746
Hillmorton Locks (N/S) SP537746–SP538744
Hillmorton Wharf SP546734
Leam Aqueduct, Braunston SP529657
Longford Junction SP359844
Lutterworth Road Aqueduct, Rugby SP504771
Newbold (Old) Tunnel SP486772
Newbold (New) Tunnel SP485774–SP486773
Newbold Arm (footbridge) SP481779

Old Swift Aqueduct (site of) SP503790
Rugby Arm (footbridge) SP502771
Rugby Wharf SP501767
Smeaton Lane Aqueduct (Stretton) SP437808
Stretton Wharf SP442810
Swift Aqueduct, Rugby SP505771
Wolfhamcote Tunnel SP527654

River Teme, Worcestershire
Powick Bridge SO836524

River Tern, Shropshire
Tern Bridge SJ553093
Upton Forge SJ559113

River Vrnwy (Afon Efymy)
Llanymynech Bridge (*Pont Llanymynech*) SJ267205
Montgomery Canal Aqueduct SJ254196

Severn (Pool Quay–Stourport) (Afon Hafren)
Atcham Bridge SJ541093
Bewdley Bridge SO787754
Bridgnorth Bridge SO719930
Bridgnorth River Quays SO718932
Bridgnorth, Underhill Street Quay SO718929
Cressage Bridge SJ594045
Coalbrookdale (Meadows) Wharf SJ666036
Coalport Bridge SJ702021
English Bridge, Shrewsbury SJ496123
Erdington Forge Canal SO734895
Iron Bridge SJ673034
Maginnis Bridge, Pool Quay SJ258115
Mor Brook (towing path bridge) SO734885
Welsh Bridge, Shrewsbury SJ489127

Severn (Stourport–Gloucester)
Bevere Lock SO837594
Iron Bridge to Bevere Island SO838595
Diglis Lock SO847533
Holt Bridge SO825633
Holt Fleet Lock SO821634
Lanthony Lock SO823183
Lincomb Lock SO822693
Maisemore Lock SO818216
Mythe Bridge SO888337
Stourport Bridge SO808711
Upper Lode SO881329
Upton Bridge (site of) SO853407

Shrewsbury Canal
Berwyn Tunnel (N/S) SJ532121–SJ538114
Longdon-on-Tern Aqueduct SJ618156
Peaty Lock SJ670136
Shucks Lock SJ668137
Turnip Lock SJ673132
Trench Incline Plane SJ684125

Shropshire Canal
Coalbrookdale Branch Aqueduct SJ695058
Coalport Basin and Quays SJ700022
Hay Incline Plane (N/S) J695028–SJ694026
Snedhill Tunnel SJ700109
Wrockwardine Wood Incline Plane SJ701122

Staffordshire & Worcestershire Canal
Hatherton Branch
Calf Heath Reservoir Feeder (N/S) SJ940097–SJ944090
Hatherton Junction SJ935086
Main line
Awbridge Bridge SO860948
Botterham Locks SO860913
Bratch Locks SO867938
Compton Lock SO884989
Cookley Tunnel SO843804
Dunsley Tunnel SO859843
Dunstall Water Bridge SJ895004
Gailey Roundhouse SJ920103
Great Hayward Junction SJ995229
Kinver Horse Tunnel SO848835
Milford Aqueduct (River Sow) SJ973215
Penkridge Horse Tunnel SJ928138
Radford Bridge Wharf SJ939216
Saredon Brook Aqueduct SJ935085
Stour Aqueduct (Kidderminster) SO829768
Stour Aqueduct (Stourton) SO864856
Stourport Basin SO810712
Tixall Quarry SJ974276
Tixall Wide (N/S) SJ988230–SJ977220
Trent Aqueduct, Great Hayward SJ994229
Wightwick Lock SO872984
York Street Toll-House SO812714
Stafford Branch & River Sow Navigation
Lock and Aqueduct SJ944227
Stafford Wharf SJ926229
Stour Branch
Pratt's Wharf & Lock SO826737
Wilden Ironworks SO825727

Stourbridge Canal
Sixteen Locks (W/E) SO889861–SO93873
Stour Aqueduct SO889859
Stourton Locks (W/E) SO863852–SO866853
Town Basin SO899848

Stratford-Upon-Avon Canal
Bancroft Basin SP205549
Brandwood Tunnel (W/E) SP065794–SP067794
Countess Coppice Embankment (W/E) P115750–SP119747
Edstone Aqueduct (N/S) SP163611–SP163608
Earlswood Lakes feeder SP114743–SP114750
Engine House, Earlswood SP113743
Kingswood Stop Lock SP187707
Preston Bagot Lock House SP177656
Shirley Aqueduct SP103781
Wilmcote Locks (N/S) SP171576–SP179566
Wootten Wawen Aqueduct SP158629
Yarningale Aqueduct SP184664

Trent & Mersey Canal
Caldon Canal
Etruria Staircase Lock SJ873468
Froghall Basin SK027477
Froghall Tunnel (W/E) SK024475–SK025475
Hazelhurst Aqueduct (over canal) SJ955534
Hazelhurst Aqueduct (over railway) SJ955535

Hazelhurst Locks (W/E) SJ948538–SJ951537
Leek Tunnel (N/S) SJ976545–SJ975544
Burslem Branch
Burslem Wharf SJ865494
Hall Green Branch
Aqueduct SJ550830
Red Bull Aqueduct SJ551831
Main Line
Anderton Boat Lift (top basin) SJ647753
Armitage Tunnel SK070164
Barnton Tunnel (W/E) SJ632748–SJ636747
Chell Aqueduct SJ796579
Church Locks SJ819560
Clay Mills (mill-race) Aqueduct SJ263267
Colwich Lock SK008211
Croxton Aqueduct SJ694672
Derwent Mouth Junction (with Trent) SK458307
Dove Aqueduct SK268269
Dutton Stop Lock SJ574787
Fradley Junction SK141140
Harecastle Tunnel (Old) (N/S) J837542–SJ848517
Harecastle Tunnel (New) (N/S) SJ837543–SJ849518
Kings Lock, Middlewich SJ707656
Lawton Treble & Hall's Lock SJ813564–SJ816562
Marston Diversion (N/S) SJ666760–SJ668757
Middlewich Wide (Big) Lock SJ702668
Middewich Locks SJ707662–SJ706658
Pierpoint Locks SJ785583–SJ786583
Preston Brook Tunnel (N/S) SJ569800–SJ573788
Red Bull Locks SJ821553–SJ826548
Saltisford Tunnel (W/E) SJ625753–SJ628754
Shardlow Wharves (W/E) SK441303–SK44303
Snapes Aqueduct SJ810566
Stoke Locks (N/S) SJ872469–SJ876459
Thurlwood Locks SJ801577–SJ804574
Thurlwood Steel Lock (site of) SJ804574
Trent Aqueduct (Brindley Bank) SK039196
Trent Aqueduct (Stoke) SJ880453
Trent Navigation (Alrewas–Wichnor) SJ172154–SJ185161
Wardle Canal bridge SJ706657
Wheelock Locks (N/S) SJ755593–SJ779584

Warwick & Birmingham Canal
Camp Hill Locks (N/S) SP085864–SP086856
Blythe Embankment and Aqueduct (N/S) SP179795–SP178789
Cole Embankment and Aqueduct (W/E) SP103847–SP104846
Cuttle Brook Embankment (N/S) SP190758–SP190754
Hatton Locks SP239668–SP269655
Knowle Locks (N/S) SP189763–SP190760
Rea Aqueduct SP082868
Saltisford Basin (site of) SP276653
Shewley Tunnel SP213672

Warwick & Napton Canal
Avon Aqueduct SP301654
Bascote Staircase Lock SP395641

Calcutt Locks (N/S) SP468636–SP468634
Itchington Arm (private) (N/S) SP426655–SP426647
Kaye's Arm (private) (N/S) SP426646–SP423642
Railway Aqueduct SP303653
Stockton Locks (W–E) SP427647–SP436652

Warwickshire Avon (Lower)
Eckington Bridge SO923423
Evesham Bridge SP040437
Evesham Lock SP041439
Chadbury Lock SP026461
Fladbury Lock SO998462
Wyre Lock SO959469
Pershore Bridge SO953452
Pershore Lock SO953455
Nafford Lock SO951419
Strensham Lock SO915405
Tewkesbury Lock SO893331

Warwickshire Avon (Upper)
Bidford Bridge SP099518
Binton Bridge SP145531
Stratford-Upon-Avon Lock (new) SP203543
Lock South Stratford (new) SP198535
Lock Luddington (new) SP167523
W. A. Cadbury Lock, Welford SP144521
Pilgrim Lock, Bidford SP122517
IWA Lock (Marlcliffe) SP089505
Robert Aickman Lock, Harvington SP067478
George Billington (lock and cut) SP064472

Worcester & Birmingham Canal
Ariel Aqueduct
Bournbrook Embankment (N/S) SP044835–SP044832
Bournville Embankment (N/S) SP051814–SP051810
Diglis Basin SO851539
Diglis Barge Locks SO848537
Dunhampstead Tunnel (N/S) SO919614–SO919813
Edgbaston Tunnel (W/E) SP053853–SP054854
Hanbury Junction SO923629
Holliday Street, Aqueduct, Birmingham SP065865
Jacobs Cut (N/S) SP017747–SP021742
Jacobs Cut Road Bridge SP018744
Lower Bittell Reservoir Dam (N/S) SP020742–SP019738
Lowesmoor Basin SO854554
Shortwood Tunnel (W/E) SP010705–SP014706
Tardebigge Tunnel (N/S) SO999698–SO997693
Tardebigge Lift (site of) SO994693
Tardebigge & Stoke Locks (N/S) SO994693–SO964680
Tradebigge Reservoir Dam (N/S) SO985684–SO983683
Tardebigge New Wharf SO996693
Upper Bittell Dam (N/S) SP017752–SP018748
West Hill (Wast Hill) Tunnel (N/S) SP048780–SP037758
Worcester Bar, Birmingham (W/E) SP063865–SP064866